ADVANCE PRAISE FOR *HOW TO LIVE
AT THE END OF THE WORLD*

"We may talk casually about the end of the world,
but Travis Holloway convincingly argues that the
Anthropocene has emerged as a new epic for our time,
offering us a narrative of human history, art, and politics
capable of shaping the beginning of a new and more
collective world."

 —Anthony Morgan, editor of *The Philosopher*

"A magnificent achievement. Beautifully written and
of our time. Going far beyond Arendt's project of
thinking a politics of the human condition, Travis
Holloway offers a radical concept of the political as a
'democracy of all of the living.'"

 —Peg Birmingham, DePaul University,
 editor of *Philosophy Today*

"A powerful and generative text that will help the reader
negotiate these disorienting times. Holloway carefully
engages with decolonial thought and with the contested
category of the Anthropocene to produce a richer sense
of the present."

 —Dipesh Chakrabarty, University of Chicago,
 author of *The Climate of History in a Planetary Age*

T0026833

HOW TO LIVE AT THE END OF THE WORLD

Theory, Art, and Politics for the Anthropocene

TRAVIS HOLLOWAY

stanford briefs
An Imprint of Stanford University Press
Stanford, California

Stanford University Press
Stanford, California

Printed in the United States of America on acid-free, archival-quality
paper

Library of Congress Cataloging-in-Publication Data
Names: Holloway, Travis, author.
Title: How to live at the end of the world : theory, art, and politics
 for the Anthropocene / Travis Holloway.
Description: Stanford, California : Stanford Briefs, an imprint of
 Stanford University Press, 2022. | Includes bibliographical
 references. |
Identifiers: LCCN 2022005568 (print) | LCCN 2022005569 (ebook) |
 ISBN 9781503633339 (paperback) | ISBN 9781503633599 (ebook)
Subjects: LCSH: Human beings. | End of the world (Astronomy) |
 Geology, Stratigraphic--Anthropocene.
Classification: LCC BD450 .H6355 2022 (print) | LCC BD450
 (ebook) | DDC 128—dc23/eng/20220214
LC record available at https://lccn.loc.gov/2022005568
LC ebook record available at https://lccn.loc.gov/2022005569

Cover design: Notch Design
Cover: Glacial ice on black sand, Iceland. Andrew Urwin | Stocksy

Typeset by Classic Typography in 11/15 Adobe Garamond

CONTENTS

HOW TO LIVE AT THE
END OF THE WORLD

A PHILOSOPHY FOR THE END OF THE WORLD

Our planet has entered into an era of instability for the first time in about 11,500 years. Biologists warn that a "sixth extinction" is underway, while geologists confirm that we have long left the Holocene, a period in the earth's history where humans and nonhumans were able to flourish alongside one another (*holos*). The geological epoch into which we have entered has been called an age of human beings or Anthropocene due to our species' destabilizing effects on life itself. In such a time, we no longer imagine a safe or sublime refuge from "nature" like Kant or Shelley.[1] We encounter intense storms and tides of algae like pendulums our species set into motion—ones that now swing back at us with a force of their own. Culturally and philosophically, we are trading in our confessions and lyrics for apocalyptic epics set in cosmic space and deep time. We think about where we'll live according to the melting of

1

glaciers. We measure critical thresholds of carbon in the air. And we talk casually about the end of the world.

In this era of ecological disaster, attempts at a new frontier are ubiquitous—flights and departures that, like Sputnik or medieval theology, promise to catapult us *out of this world*. An Instagram ad pops up with a single white man sitting *padmāsana* before the bare, amber plateaus of the American Southwest. A different ad on my way to work invites me to be a "pioneer" on "a new frontier." Elon Musk. Richard Branson. The Fyre Festival. And, of course, governments that abandoned their constituents and the planet long ago. "From the 1980s on," describes Bruno Latour, "the ruling classes" "concluded that the earth no longer had room enough for them and for everyone else . . . [They] stopped purporting to lead and began instead to shelter themselves from the world. We are experiencing all the consequences of this flight, of which Donald Trump is merely a symbol . . . The absence of a *common world* we can share is driving us crazy."[2]

This absence of a common world or *worldlessness*—this iteration of capitalism in which the state is *of* and *for* financial markets and daily life is measured in terms of self-entrepreneurship[3]—has left many of us alone and seemingly unable to respond to every major looming challenge. A sense of climate despair[4] and faithlessness in government[5] is widespread around the globe, particularly among young people. From hurricanes to pandemics, from mutual aid projects to doomsday bunkers, a growing number of people feel that their governments will

likely not prevent the next disaster or in some cases even try to save them from it. And yet, climate change is also intruding on these systems of governments from the outside, disrupting them and reconfiguring them. It is simultaneously bringing us together in unprecedented ways with a shared threat and a new sense of history.

Just when another world no longer seemed possible, it became inevitable. In truth, a new (climatic) regime will be forced onto our systems of government in this century whether we act or don't, whether we want it to or not, and sadly, whether we are more or less responsible for climate change and more or less able to shelter ourselves from it. It seems likely that this new era will increase our disparities and make all of our problems far worse. But is it also possible to imagine, in the face of a common catastrophe, the creation of more just and equitable worlds? Could living at the door of this shared crisis compel us to change the way we treat one another and the earth? We need a different way to live, think, and assemble in this new era—nothing less than a philosophy for the end of the world will do. We need to consider this moment of transition in a way that sharpens our understanding of it, touches us, and introduces the possibility of a different future.

FLIGHTS FROM THE WORLD

Not unlike the billionaires' space race of 2021, the political philosopher Hannah Arendt began *The Human Condition* (1958) by reflecting on the first artificial satellite in

space. Arendt described the launch of Russia's Sputnik satellite as a turning point: "an earth-born object made by man . . . [had been] launched into the universe."[6] Still, what shocked Arendt intellectually was that the common response to this moment of "human power and mastery" was not pride or awe, but "relief about the first 'step toward escape from men's imprisonment to the earth.'"[7] The sentiment, Arendt remarked, was "extraordinary."[8] For "although Christians [had] spoken of the earth as a vale of tears and philosophers [had] looked upon their body as a prison of mind or soul, nobody in the history of mankind [had] ever conceived of the earth as a prison . . . or shown such eagerness to go literally from here to the moon."[9]

The 2021 space race among billionaires Richard Branson, Elon Musk, and Jeff Bezos gave us a sense that the desire for similar departures will grow as the world gasps and roils in catastrophe.[10] Still, the 2021 space race also clarified a significant *mutation* in our desire to flee Earth since the publication Arendt's *The Human Condition* in 1958. After Sputnik, there was the declaration in Russia that "*Mankind* will not remain bound to the earth forever."[11] Similarly, the American astronaut would famously announce, "That's one small step for man, one giant leap for *mankind*." Our era is different in an important respect: Today it is not *humankind*, but wealthy *individuals* who imagine taking flight from the earth or living in a colony on Mars. Only they, despite a pandemic that would seem to spare no one, can seclude

themselves on private islands to avoid a virus,[12] receive life-saving therapeutics that are otherwise unavailable to the public,[13] or make considerable wealth in financial markets during a global shutdown.[14] Or go to space, of course. In 1958, Hannah Arendt remarked that "*mankind*" itself was experiencing "world alienation"—a collective flight from the earth into the universe that signaled its very "repudiation" of its earthly "habitat."[15] This common or collective notion of *humankind* is, for the most part, absent in our own era. Except, of course, in the name and inherent within the geological epoch of the Anthropocene.

In this particular regard, what the Anthropocene narrative offers is extremely tempting. For those of us who are not wealthy enough to start a colony on Mars or "shelter [ourselves] from the world," as Latour put it, the Anthropocene puts an end to the fantasy of sheer individualism, worldlessness, and human exceptionalism once and for all.[16] The Anthropocene epic tells us that human beings were never separate from nature, nor do we live as individuals. It describes human beings as a collective force and situates us in a web of life. The Anthropocene also introduces a shared sense of time and events after the so-called "end of history." This includes an eschatology that collectivizes, historicizes, and politicizes the public before the growing threat of climate change, offering what some believe is a new approach to solidarity at a time when solidarity has been difficult to find or produce. This new sense of time (chapter 1) and narrative

(chapter 2) begs for a specific form of politics to address it (chapter 3). And so, while many have taken issue with the name Anthropocene for good reasons,[17] there is also a wonder, a sense, a desperation, perhaps, among some about whether this awful Anthropocene, or whatever we call this new period in our planet's history, might also hold unprecedent possibilities for a different way of life or philosophy for the end of the world.[18]

A philosophy for the end of the world could mean many different things at once. It could mean learning how to think beyond our own experience of the "world" in order to think about deep, planetary history. It could mean a responsibility to narrate the end of the Holocene and the birth of the Anthropocene, or whatever one chooses to call it. It could mean a form of politics—a state that redirects public funds away from fossil fuel subsidies, for instance—or a call to "begin the end of the world," as Aimé Césaire once wrote. One hopes, ultimately, it could come to mean a *post*human condition where forms of life that were thought to be beneath us or "worldless" could appear alongside us in the public sphere.[19]

THE PROJECT OF THIS BOOK

In this book, the phrase "the end of the world" will be understood in an open or polyvalent sense in the three chapters on time, art, and politics. These three essays are bound by a common theme: they are all a response to the

end of the world as we know it against the specter of cata-
strophic climate change. Folding the history of gender,
race, colonialism, and capital into geological time, it uses
the philosophical method of genealogy to retell the story
of human beings in the Anthropocene and direct us
towards ways of life that are outside of it. Examining con-
temporary art, it considers how today's reinvention of
epic marks a transition out of postmodernity and chal-
lenges us to face climate change collectively. The final sec-
tion on politics proposes a form of democracy that will
have to be won and yet transformed into a *zōocracy* (from
zōē and *kratos*), a rule of all of the living that includes
posthuman delegations. This book is not intended to be a
comprehensive study of the Anthropocene, or philoso-
phy, for that matter. Nevertheless, it considers how we
might reclaim the geological term "Anthropocene" and
revise our way of life in view of it. But why take up a con-
troversial and obscure term like the Anthropocene at all?

The philosopher Jacques Derrida once remarked that
our responsibility at "the end of the world" will be "to
change all [the] names . . . that will come upon us,"
"beginning with 'ours'"—these "names . . . will come
upon us more than we . . . choose them," he added.[20] As
Donna Haraway put it differently in *Storytelling for
Earthly Survival*, "[The word] Anthropocene is in play.
It's a good enough word . . . So I would have done it dif-
ferently . . . We work with what we've got."[21] When one
commits to changing the meaning of words like "Anthro-
pocene" or "democracy," as Jacques Derrida wrote in

another context, we are choosing to become "delegates of [a] word" or inheritors of a word, even as "[w]e do not yet know what we have inherited."[22] This sense of inheritance or commitment is akin to the art practice of *détournement*.: to appropriate words like Anthropocene or democracy and reclaim them, renarrate them, reroute or even hijack them. Taking up the word Anthropocene in this way would require a certain rethinking of *anthrōpos* and its history, as well as wrestling with a way of thinking in philosophy, history, and politics that has limited the "world" to a "specifically human" or "man-made world."[23] What I argue in the conclusion, based on the work of Michel Serres and others, is that philosophers, historians, and political theorists have not yet "spoken of the world: instead they [have only] endlessly discussed men."[24]

A solution to this problem, to matter at all whatsoever, cannot take the form of a flight or escape from our world (either in thought or in practice) into outer space, a distant time, or the universe. We must find a way to think that does not "confine [itself] to . . . an analysis . . . of the human condition," as Hannah Arendt wrote of her project in *The Human Condition*, but one that, on the other hand, does not make the mistake Arendt warned us about after Sputnik: withdrawing entirely from "the frailty of human affairs" on Earth.[25] As Jeffrey Jerome Cohen puts it brilliantly in *Stone*, we require a way of thinking that knows that "the world is not for us. [That the] play has been long, and we are latecomers. Yet it is easy to go too far, to lovely only unpeopled ecologies . . .

That perspective is just as partial, and repeats in a secular mode a medieval theology that enjoys disdain of the sublunary world, that takes pleasure in declaring human lives insignificant."[26] On the one hand, we need an approach that stays in the fray of things with nonhumans—what Donna Haraway calls *staying with the trouble* with fellow critters or oddkin on Earth.[27] On the other hand, we need to know how to be human *at* the end of this "world." We need to know how to live, think, assemble, love, repair, eat, enjoy, mourn, and die in the Anthropocene.

This book uses this approach to rethink three perennial questions for the humanities—time, art, and politics—for a new geological and political moment. The first chapter on history recounts and reperiodizes the new grand narrative of our time: the birth of the so-called Anthropocene. One reason for doing this is to correct the story of the Anthropocene—to clarify who and what is responsible for it. Another, less obvious reason is to think about why it seems important today to tell *this* type of story—a geological epic—and to engage with the question of how we should tell it. In contrast with a neoliberal culture of confessional and entrepreneurial narratives, and well beyond the so-called *petits récits* or little narratives of postmodern society, the Anthropocene epic narrates a history of our entire species and folds this story into geological time.[28] I propose retelling this epic with tools from philosophy's counterpart to geological dating, the genealogical method, which periodizes segments of

time and events in a more differentiated way and in terms of power and resistance. Using these tools, I critique a universalizing, colonialist account of the Anthropocene that Kathyrn Yusoff has called "White Geology,"[29] and offer a contrasting historical narrative, a counterhistory, for human beings in the Anthropocene. To tell this story differently, I engage closely with the fields of postcolonial theory, Black studies, and feminist theory, and I utilize certain resources for historical modes of thinking in contemporary Continental philosophy. The aim of this chapter is not merely a critique or a new understanding of the Anthropocene. It is a map or cartography that directs us towards ways of life that are outside of it.

In the second chapter on art, I consider an emerging mode of art in which human beings are exposed to the elements in a new way. I focus specifically on new works of art and narrative about strange weather. Odd weather is one of the growing ways human beings *experience* climate change phenomenologically or beyond abstract scientific data.[30] Even those who do not "believe" in climate change experience it. The weather is also one of first things human beings talk about with one another or share narratively, today and at least since the great flood in the Epic of Gilgamesh.

I open the second chapter on art by considering a contemporary play about the reinvention of epic in which human survival depends on the weather. I then examine a series of contemporary works of art about strange weather as a microcosm of a certain reinvention of epic in our

time. I argue that a new kind of epic is being written by contemporary artists like Octavio Abúndez, Sarah Anne Johnson, or Anne Washburn, one that displaces the primacy of the personal lyric once more. I attempt to situate this art in a unique historical context in order to better understand the kinds of stories we are telling each other in this new era. A new body of art seems to differ from the threat of nature imagined by those before us. Immanuel Kant, for example, once described the experience of thunderstorms as *sublime* due to the human ability to find safe harbor from nature in the mind. By contrast, contemporary works of art often leave us vulnerable and suspended in the moment before we can be "marked safe." The elements no longer confront us as individuals, but as a species. They do not turn us inward, but leave us exposed. They do not suggest an individual's triumph over nature, but a coming blow to any or all of us. I outline five practices that appear to describe the emerging traits of an art beyond postmodern art—works of art that mark the resurgence of metanarrative after postmodernism, on the one hand, and also extend postmodern creative practices like appropriations and constraints into what I will call, with an asterisk, *postromantic* practices. As Isabelle Stengers describes in *In Catastrophic Times*, "We are no longer dealing (only) with a wild and threatening nature, nor with a fragile nature to be protected, nor a nature to be mercilessly exploited. The case is new."[31] I conclude by considering different ways of looking at clouds.

The final question of this book is whether the specter of climate change, and the collectivization and politicization it creates against the prospect of impending catastrophe, has the potential to bring us together and motivate political reforms in ways that were unthinkable or impossible in prior decades. In the third and final chapter on politics, then, I consider the political possibilities for a new era or epic of "human beings" in the Anthropocene. This chapter begins with W.E.B. Du Bois's "The Comet," a short story about the end of the world that was written in the midst of a flu pandemic and the White supremacist violence of the Red Summer. Du Bois's desire for an end to the White world launches a new and very different kind of worldmaking that does not depend on human exceptionalism and its exclusions. I consider the worlds that must be ended—the Capitalocene, the Plantationocene, and others. I discuss the ways in which forty years of neoliberal capitalism has left many of us worldless, on the one hand, and yet actively subsidizing fossil capitalism with public funds, on the other. Still, I argue that the Anthropocene hastens an exit from neoliberal life that might not have been thinkable or achievable before, and that a philosophy for end of the world requires directing a new sense of collectivity and history towards a radical form of democracy on the part of human beings.

By democracy, to be clear, I mean a form of politics that would contest or *detourn* a failed, forty-plus-year experiment in privatization and technocratic govern-

ment, or rule by market experts. I mean a form of politics that was described by Plato as "oligarchy's enemy" and one that "comes into being when the poor win"[32]; a political system where "the rich put up the money"[33] to "build a great and beautiful city";[34] and which Plato very curiously says amounted to a certain freedom from human sovereignty "being planted in the very beasts."[35] I also mean a form of politics that resists ethnic notions of a "people" because it "throws open [its] city to the world," as Thucydides put it;[36] it "[has] put slaves on equal terms with free men and metics with citizens," cried the "Old Oligarch," and it has applied "the law of equality...in the relations of women with men," lamented Plato.[37] Still, in the end, I argue that a rule of the "people" or *dēmos* is not sufficient by itself for an Anthropocene. Humans must somehow learn how to appear en masse in a public space that was never divorced from its environs; we must cultivate forms of association that are not based upon a separation between the human species and its others.[38]

In sum, I argue that a radical form of democracy must not only be conceived of and won, but transformed into a *zoocracy*, a rule or assembly of all of the living. What I mean by zoocracy is a rule of *zōē* or life itself that gives and sustains life. It would be more than a rule of a people or *dēmos*, even more than a rule of human beings or *anthrōpoi*, that is, more than the rule of a specific and superior form of life (*zōon politikon; zōon logon echon*), as Aristotle described human beings in his *Politics*. This would require organizing towards a form of power that

would be possible only if millions of humans begin to *appear with* the full and monstrous force of their environments. An array of time-honored cosmologies, hierarchies, and histories narrate a different story, of course: that other forms of life are somehow separate from us, outside of our political realm, or beneath the dignity and rank of human beings. But today it is simply no longer possible to write other forms of life or the planet outside of our public sphere. In fact, we don't even have to envision a "democracy...extended to things" or a "parliament of [nonhuman] things," as Bruno Latour put it in 1993,[39] because the climate change we've been hearing about for decades is now here, getting worse, and announcing a new political forum that humans have yet to join seriously. We will have to invent the names, practices, and institutions for such a politics—zoocracy, geocracy, posthuman delegation, "parliament of the living."[40] This is the difficult work that remains to be done, but all of the elements are already here for it.

Thank you for reading and for this opportunity to think about the end of the world together.

1 TIME: A COUNTERHISTORY FOR HUMAN BEINGS

A GENEALOGY FOR THE END OF THE WORLD

We live in a period of history that is defined, supposedly, by what it means to be *human*. In contrast to critical works from the last century that theorized the end of a certain *humanism*, or split that humanism into at least two, major works from the last decade like Yuval Noah Harari's *Sapiens*, Elizabeth Kolbert's *The Sixth Extinction*, or Amitav Ghosh's *The Great Derangement* narrate an epic about what it means, historically, to belong to the *human species*. It was neither theorists, writers, or film-makers, but geologists who presented the most promi-nent and accessible narrative about this new "age of man." Their story begins after the last glacial period, or about 11,500 years ago, when the Earth entered into a relatively stable climate period known as the Holocene— a period in which human civilization was able to flourish

in a temperate climate alongside the rest of the earth, or a period of *holos*.[1]

Then, at a February 2000 meeting of the International Geosphere-Biosphere Programme, the Nobel prize-winning atmospheric chemist Paul Crutzen proposed that we were living in a new geological epoch: "We're no longer in the Holocene, but in an Anthropocene!"[2] In an article published that year called "The Anthropocene," Crutzen joined with the ecologist Eugene F. Stoermer to argue that we had entered into a new, human-dominated geological epoch in the Earth's history; they posited that this geological period began with the invention of the steam engine (and its use of fossil energy).[3] By 2016, a group of prominent geologists had formally concluded that the earth had entered into a new era, the Anthropocene, so named because it is an age defined by humans' impact on the planet.[4] The consequences of Crutzen and Stoermer's proposal for a new geological epoch—an "Anthropocene," an age of humans or *anthrōpoi*—went well beyond the scope of geology itself. They had introduced a new epic for our time. This epic erased the customary distinction between human and natural history and folded our species into geological time.

I think one of the pressing tasks confronting philosophers today is to engage seriously with the periodization of this new geological epoch, the so-called Anthropocene or age of human beings, and offer a contrasting narrative of what it means to be a human being in this era. Like the geologists who are attempting to date and describe

the birth of the Anthropocene epoch, philosophers have tools for periodization and historical description that lead them to tell the story of *anthrōpoi* in a significantly different way. The philosophical counterpart to geological dating, *genealogy*, attempts, as Nietzsche described it, to "distinguish between periods" and to "know the conditions from which . . . values have sprung and how they developed and changed."[5] But unlike the predominant narrative of the Anthropocene, philosophical genealogies and counterhistories interpret prevailing historical narratives with suspicion, differentiate between those with power and those without it, and search for alternative "discontinuities" or transitional events. And whereas master narratives about history often leave us with a false, immobilizing sense that no past or future exists outside of them, counterhistories direct us to ways of life that are external to these narratives.

My specific intervention is to sketch a genealogy or counterhistory of what it means to be a human being in the Anthropocene epoch. Thus far the predominant Anthropocene narrative, put forward by atmospheric chemists, stratigraphers, and historians, has focused on the ecological impact of human beings as a *totality* or *species*. This narrative has been accused of obfuscating the ways in which "man" has historically been differentiated in terms of power, subjugation, and responsibility. To begin with, it has told a supposedly universal story of man from the point of view of Europe and the Global North, and it has omitted entirely the perspective of

what Sylvia Wynter once called the "Human Other."[6] Using the resources of genealogy and other historical modes of thought, I propose a counterhistorical narrative of anthropogenic events. This project would endeavor to excavate an unrecognized archive—of colonization, slavery, plantations, fossil capitalism, heteropatriarchy, war, and other scenes of power and subjection—in the geological strata of the Earth. For example, from the fifteenth to the seventeenth centuries, the genocide of the indigenous peoples of the Americas and the reforestation of their land is actually registered by an unlikely decrease in carbon dioxide in the ice cores from the same period.[7] What else are we able to document or know in this way?

In addition to wanting to tell the Anthropocene story *differently*, I am especially interested in the kind of story we are telling—a geological epic—as well as how and why we are telling it. The Anthropocene story shifts our narratives away from individual life, literary confession, and human capital towards the oceans that surround us and the histories beneath our feet. In an era of capitalism that depends on self-capital and self-entrepreneurship, the Anthropocene offers a poetics that collectivizes and politicizes us, and marks an end to the end of history. On the one hand, a narrative like this holds a certain promise for helping us see ecological or political issues not just through the lens of private concerns or individual moral responsibility, but in terms of an entire biosphere, and in terms of the kind of collective actions that we must take

if we are to prevent further catastrophe and act better in its midst. On the other hand, any story that has the potential to collectivize us must simultaneously be *differentiated* in terms of power and capital if it is to be of any real use.

This is precisely where genealogies or counterhistories for the Anthropocene can help. Genealogies lie *in between* the *collective* and the *differentiated*. Like the Anthropocene, genealogies do not begin with my own subjective life; as Michel Foucault put it, they "[d]o not ask who I am and do not ask me to remain the same."[8] Yet unlike the predominant, totalizing narrative of the Anthropocene, genealogies periodize segments of history with a particular view to power relationships or power differentiations. Nietzsche, for example, studied how upper-class Germans developed a system of morality that would elevate themselves over "bad" Germans (the lower class); Foucault attempted to locate the moment when "mad" people were distinguished from "rational" people in a similar way. A philosophical genealogy of human beings in the Anthropocene is needed to rewrite the story of the Anthropocene with subaltern histories and more anthropogenic events, and to better specify the distinct cultural, historical, and political processes that have brought us to this place. Ultimately, what I am proposing here is a certain philosophical inheritance of the term Anthropocene that reappropriates or detours its predominant narrative—with the hope that this might lead to a different future.

INHERITING THE ANTHROPOCENE

After an experience with wildfires in 2003, the Marxist historian and postcolonial theorist Dipesh Chakrabarty described "falling into 'deep history,' into the abyss of deep geological time."[9] Chakrabarty turned to scientific articles written by geologists to figure out how to add to his research on colonialism, globalization, or "human history," as he put it, a set of historical concerns that were of an entirely different time scale or chronology: He would try to "render" as "layered . . . [t]he geological time of the Anthropocene and the time . . . of global capital."[10] Chakrabarty, a historian, set out to inherit the geological science of the Anthropocene and to rethink concepts that were key to it like geological force, deep history, and species thinking.

In his landmark 2009 essay entitled "The Climate of History: Four Theses," Chakrabarty considered the Anthropocene in the context of history, philosophy, and the humanities more broadly. His key insight was that historians and theorists had made the mistake of viewing human history as separate from the history of the planet; instead, Chakrabarty argued, we had to learn to think about human beings as having a "geological force," and, to do this, we had to think about human beings *collectively* as a species.[11] Our geological force meant that we could no longer disregard our species' effects on the planet. At the same time, we could no longer describe human history as unaffected by natural history either. In

sum, the routine distinction between human history and natural history had to be collapsed. As Chakrabarty famously concluded in "The Climate of History," there is "an emergent, new *universal history of humans* that flashes up in the moment of the danger that is climate change."[12] For Chakrabarty, to experience the "shared sense of catastrophe" in our planet's history necessitated the "question of a human collectivity, an us" in the entrance to the Anthropocene.[13]

Chakrabarty, of course, had up to this point been a "child of [a certain scholarly] tradition"—one that was "extremely suspicious of all claims of totality and universalism."[14] Nevertheless and despite all of this, for Chakrabarty we had to think about the *totality* of our species as a *collective* geological force in a new *universal* history of climate change. As the Marxist and postcolonial theorist would try to carefully underscore, in contrast to universal theories of the Enlightenment, this human collectivity or "we" was not a universal that we could ever lay claim to;[15] it was "unlike a Hegelian universal . . . [and] cannot subsume particularities"; it did not contain "the myth of a global identity"; nor did it elide the gap between rich and poor, White and Black, and so on.[16] It was a *negative* universal history that, he said, could not oppress other particulars with a totalizing view of the whole like Kant's "universal history" or Hegel's "world history," both of which, he himself had argued, had to be provincialized.[17]

Some, like the celebrated Indian author Amitav Ghosh agreed with Chakrabarty's position, writing: "Anthropogenic climate change . . . is the unintended consequence of the very existence of human beings as a species. . . . [G]lobal warming is ultimately the product of the totality of human actions over time" and "[e]very human who has ever lived has played a part" in it.[18] Others, however, disagreed strongly. In *The Shock of the Anthropocene*, Christophe Bonneuil and Jean-Baptiste Fressoz argued that Crutzen's "Anthropocene" and Chakrabarty's "universal history of humans" reinscribed and gave force to a wealthy, White, Eurocentric, and revisionist narrative of history. To begin with, the Anthropocene narrative presented "an abstract humanity uniformly involved . . . and uniformly to blame" for catastrophic climate change.[19] Meanwhile "Chakbrabarty," they wrote, "formerly a Marxist historian and a leading figure in subaltern studies, explained that the main critical categories he had previously applied to understand history had become obsolete in the time of the Anthropocene. . . . [B]y placing humanity in the narrative as a universal agent, indifferently responsible, [Chakrabarty abandoned] the grid of Marxist and postcolonial reading in favour of an undifferentiated humanity."[20] The geological action of the human species, they argued, "is the product of cultural, social and historical processes," and for this reason "an undifferentiated *anthrōpos* as the cause of the Earth's new geological regime is scarcely sufficient."[21]

Elsewhere, Kathyrn Yusoff argued in her 2018 book *A Billion Black Anthropocenes or None* that the Anthropocene narrative was "White Geology" pure and simple. "To be included in the 'we' of the Anthropocene is to be silenced by a claim to universalism that fails to notice its subjugations," argued Yusoff.[22] Yusoff showed that rather than being an agent of the age of humans or an "Anthropocene," being Black and subjugated meant belonging to the realm of the *inhuman*. She presented a counterhistory, a "Black Anthropocene," that narrates a division between the human and the inhuman and tells the stories of the inhuman. What is needed, she wrote, is a "redress to the White Geology of the Anthropocene" that neutralizes, consolidates power, and reclaims "innocence" in its name.[23]

In the end, these criticisms only reinforced the sense that a new epoch is upon us. The Anthropocene has ushered in a different type of story—a geological epic—that collectivizes us, historicizes us, and ends the idea of a separate human "world," or a world that is distinct from its environment. After decades of neoliberal government and economic individualism, could this new sense of history help us break up the concrete of our culture of the self and rebuild public spheres that include something like what Michel Serres calls a "natural contract"?[24] Could we build the kinds of worlds, this time around, that do not destroy someone else's world or divide a world into two (and into two species)? How do we respond to a historical moment marked by growing climate despair[25] and

distrust in neoliberal government[26] with something other than entrenched borders or identitarian nationalisms? My wager is that this begins at least in part with a counterhistory for human beings. Such a counterhistory would not take the form of a meditation on time or history before or without human beings. It would begin with more accurate anthropogenic events and subaltern histories, and it would culminate in a form of politics at the end or limit of the world.

DIFFERENT NAMES, STORIES, AND CONCEPTS FOR THE ANTHROPOCENE

How might we tell the story of the Anthropocene more accurately? How could we stitch a *muthos* about human beings that narrates what has actually brought us to this place? Some think a better narrative begins with the name, the title of the story.[27] "Naming can . . . be a covering over," writes Kathyrn Yusoff.[28] Nothing less than "the story of the Earth is at stake" in this name, adds Donna Haraway.[29] "Surely such a transformative time on earth must not be named the Anthropocene!" she writes.[30]

For many, the name Anthropocene implies a universal, undifferentiated, and equally responsible *anthrōpos*. As an alternative, Anna Tsing, with others, has offered the name Plantationocene to describe a development that brought together colonialism, slavery, capitalism, heteropatriarchy, and White supremacy in order to exert a new kind of control over the land.[31] In *The Shock of the Anthropocene*,

Bonneuil and Fressoz offer a host of alternative names, including Thanatocene, which would begin this story as an age of war; or Anglocene, since Great Britain and the United States made up 57 percent of all emissions as recently as 1950.[32] Haraway, among others, has argued that "if we could only have one word for these . . . times, . . . surely it must be the Capitalocene."[33]

Naming is also, of course, an attempt to date and describe something at the moment of its birth, or what in philosophy is called genealogy. Like the stratigraphers who search for "Golden Spikes" that begin geological epochs (i.e., the agricultural revolution, the birth of the steam engine, etc.), philosophers like Nietzsche, Foucault, and others have long taught us how to search for events, ruptures, or discontinuities that indicate the transition from one period to another. One example of how genealogies can contribute to the Anthropocene narrative is to renarrate the major anthropogenic events or Golden Spikes of the Anthropocene in terms of power relationships and power differentiations. For example, if the major anthropogenic events are identified by geologists as the "Columbian exchange" or the dawn of the nuclear age, Kathyrn Yusoff provides a genealogy or counterhistory of these periods in *A Billion Black Anthropocenes or None* by showing that Christopher Columbus carried slaves on his second voyage to the Americas, and that the United States conducted early nuclear testing on the Marshall Islands precisely because the US did not count the indigenous population there as fully human. Yusoff

differentiates the story of the Anthropocene in terms of the human and the "inhuman."

In addition to contesting the Anthropocene narrative, and offering a counterhistorical narrative of anthropogenic events that includes the shadow archives of the inhuman, philosophers have also developed a number of concepts that are helpful for this geological epoch.[34] Donna Haraway's work is flooded with new concepts like critters or kin, whom she defines as fellow "earthlings . . . in the deepest sense," and whom we "make-with, become-with, compose-with."[35] Yusoff introduces the notion of the "geosocial," or the way in which racial, gender, sexual, and class differences are inscribed in the strata of the earth. Concepts like these clean the rearview mirrors and expose the blind spots of Modern philosophy and a certain humanism, and they are a foray into new avenues for thought and art in this epoch. As Haraway remarks, what this new epoch finally makes indisputable is that "human exceptionalism and bounded individualism, those old laws of Western philosophy and political economics, [have] become unthinkable."[36] We can no longer pretend to be "good individuals in so-called modern Western scripts, act[ing] alone."[37]

FOR A COUNTERHISTORY OF HUMAN BEINGS IN THE ANTHROPOCENE

In lieu of renaming the Anthropocene just yet, what I am proposing is a certain philosophical inheritance of the

term: a more accurate counterhistory of *anthrōpos* (and its other) for the anthropogenic period in question, that is, at some point over the last 550 years or so. Foucault offered us one account of the invention of "man" in *Les mots et les choses*, or what he called "an archaeology of the human sciences." Elsewhere, Rosi Braidotti reminded us that Foucault's idea of "man" from the Renaissance to the nineteenth century was always a particular idea of man: a "male . . . assumed to be white, European, head of a heterosexual family and its children, and able-bodieda full citizen of a recognized polity."[38] Still, it was Sylvia Wynter who racialized and contextualized this notion of man in the context of its colonial other, laying out a trajectory for thinking what she referred to as "the Human Other."[39]

Wynter wrote, "the new 'idea of order' . . . enacted by the dynamics of the relation between Man . . . and its subjugated Human Others (i.e. Indians and Negroes) . . . was to be brought into existence as the foundational basis of modernity."[40] She continued: "[I]t was to be the discourses of this knowledge, including centrally those of anthropology, that would function to construct all the non-Europeans . . . as the physical referent of . . . its irrational or subrational Human Other to its new 'descriptive statement' of Man as a political subject."[41] According to Wynter, "the West's transformation of the indigenous peoples of the Americas/the Caribbean (culturally classified as Indians, indios/indias), together with the population group of the enslaved peoples of Africa, transported

across the Atlantic (classified as Negroes, negros/negras) . . . that of the Human Other to . . . the ostensibly only normal human, Man."[42]

For me, some of the most compelling passages of Kathryn Yusoff's *A Billion Black Anthropocenes or None* are the clarion moments when Yusoff draws upon Wynter's conception of "man" in the context of the Anthropocene, explaining that to be Black, indigenous, or enslaved during these years meant to fall outside of the human or *anthrōpos* in a supposed Anthropocene. It was a division between the human and the *inhuman*, she argues, which we can register as early as 1493 or Columbus's second voyage on which he carried slaves, that should begin the era of the *anthrōpos* or the Anthropocene.[43]

In the context of the Anthropocene debate, then, we must listen to Wynter, Yusoff, and others as they contextualize what it has meant to be human and when. Both tell counternarratives of those who were othered, colonized, or subjugated by what it meant to be "human" in the context of Renaissance humanism and European Enlightenment thought. Still, one must be equally careful not to describe the Anthropocene as a Eurocene, or as something that originated in Europe and then spread throughout the world. As Dipesh Chakrabarty argues at great length in *The Climate of History in a Planetary Age*, the idea of Europe or European "man" as a starting point for the Anthropocene is false, imperialistic, and must be provincialized. Chakrabarty writes:

Latour speaks of "provincializing modernity" as a European task: since Europe brought it about and spread it throughout the world, it is now the European intellectual's task to "provincialize" it, to put it back in its proper place. But, as I argued in *Provincializing Europe*, Europe was not the only originator of modernity; third-world intellectuals who took heart from what they saw as the universal side of certain European ideas were cooriginators in the process. . . . The anticolonial desire to modernize was not simply a repetition of the European modernizer's gesture.[44]

In defining the historical event that gave rise to the Anthropocene, many begin with the use of coal in Britain or the Industrial Revolution. Others, such as Simon Lewis and Mark Maslin in their article, "Defining the Anthropocene," focus on the effects of European colonization as a possible historical starting point for the Anthropocene.[45] Chakrabarty, however, shows that anticolonial state developments of the last century were just as fossil-fuel-driven, if not more so, as imperialist state development projects had been.[46] He cites alternative starting points for the Anthropocene that do not begin in Europe—for example, global human agricultural practices or large-scale burnings.[47] Finally, and most importantly for us in this study, he notes that the Anthropocene is not somehow simply the result of Modern European philosophy or a European way of life taking root in the psyche of colonized subjects.

In contrast to other theorists who have emphasized a European humanism at the dawn of the Anthropocene,

Chakrabarty explains that we find a similar narrative to Renaissance humanism in works like Rabindranath Tagore's *The Religion of Man* (1931).[48] Like Pico della Mirandola in *On the Dignity of Man*, Tagore's *The Religion of Man* describes humans at the center of things, as exceptional, and as the viewer of all or the whole.[49] Since Tagore's philosophical work does not replicate or derive from European ideas, here we see how the philosophy of human exceptionalism—the masculinist conquest over other species and "nature"—is found in multiple places, separately.

As Chakrabarty summarizes, "Europe was not the only originator of modernity."[50] The anticolonial modernization projects of Mao, Nasser, Nyerere, and others did not originate in or derive from European colonization. Likewise, he says that we see this in Nehru's mystical obsession with damming the Himalayas, or today with Modi finding inspiration from passages in the Vedas for coal-fueled development projects. What this shows, Chakrabarty argues, is a separate, "third-world desire for energy-intensive, mostly fossil-fuel-driven modernization."[51] Moreover, as Kathleen Morrison argues in her essay "Provincializing the Anthropocene," European agricultural practices or European industrial history (typically Britain's) cannot be taken as an accurate starting point for the Anthropocene either. Morrison cites practices and events outside of Europe as possible starting points, such as evolutions in things like vegetation or livestock farming that "has made possible new configurations of human population."[52]

As we seek to *differentiate* the narrative of the Anthropocene with more accurate anthropogenic events, then, we must resist the temptation to reduce the entire Anthropocene to a Eurocene and universalize it. Instead, we must pursue plural beginnings and multiple stories for the Anthropocene, just as we require plural or multiple chronologies of human and geological histories for it.[53] This is particularly important when one is attempting to locate the historical birth or births of the Anthropocene—one of the crucial tasks of any genealogical work. To pursue a more accurate, more provincialized account of the Anthropocene, we must tell multiple stories of anthropogenesis and look outside of Renaissance humanism and European colonization. We need these stories to better locate systems of ideas, ways of being, and specific anthropogenic events that account for the actual birth or births of the Anthropocene.

CONCLUSION: PHILOSOPHY, TIME, AND THE ANTHROPOCENE

Philosophers have a significant role to play in inheriting, debating, and legislating a word that has introduced a new grand narrative for our time. For despite our increasing numbers as a species being one of the most significant drivers of climate change, we confuse ourselves at our own peril if we think of our entrance into the Anthropocene as a species event, or something that has

been brought about by *anthrōpoi* in general. It was not. The Anthropocene was a series of historical and political events and processes involving the exercise of power and the subjugation of others and nonhumans. Consequently, geologists and theorists who narrate a geological history of human beings as a supposed universal retreat from the specificities and processes that allow us to know this history and to change it.

Like the geologists and stratigraphers attempting to date and define the Anthropocene, philosophers have historical methods and tools that might provide a more accurate account of the Anthropocene epoch. Because genealogies account for the differences between those with power and those without it, they can be political, racial, queer, gendered, class-based, postcolonial, and subaltern. They can pay careful attention to the way a term or idea like "man" is used not only in the context of power, but also in the context of resistance. "Everything that exists," Nietzsche described, "is periodically reinterpreted by those in power in terms of fresh intentions."[54] "[T]he whole history of a thing is . . . a sequence of . . . appropriation, including the resistances used in each instance."[55] In other words, as we inherit and debate the proposed Anthropocene, we must think about who defines "man" and when and for what purpose, who finds themselves on the other side or outside of this definition, or who resists this definition of man and for what purpose. One thinks immediately of works like Pico della Mirandola's *Oration on the Dignity of Man*, composed in

1486 and published in 1496, as well as the work of Sylvia Wynter or Kathyrn Yusoff, each of whom resist and provide a counterhistory for Pico and others' idea of "man."

Still, as we have seen, the Anthropocene is not simply a Eurocene and it requires multiple stories. Since human exceptionalism, as an idea, is in no way proper to European Modernity, it is important that we excavate this idea across multiple texts, cultures, and traditions. Another problem with the Anthropocene narrative is broader than this, however. This new story of the geological force of human beings must include other forms of life and multispecies narratives. And despite the proliferation of areas of study that differentiate human beings over the last several decades—postcolonial theory, critical race theory, queer theory, feminism, etc.—these areas have mostly remained focused on human beings alone and have been oblivious to their environments.[56]

A truer and more comprehensive counterhistory for the end of the world, then, would need to think through the limits of a world that has been defined as a separate domain of human beings alone. Although the project above has been primarily focused on a certain philosophical inheritance of an Anthropocene—an attempt to change the meaning and narrative of its *anthrōpos*—we know that stories must also be told about nonhumans, oceans, and stone. One example of this is Elizabeth Kolbert's well-known book *The Sixth Extinction*. Another is Jennifer Telesca's more recent *Red Gold* on the "managed extinction" of the giant bluefin tuna by government

organizations.[57] The actual realism of works like Telesca's *Red Gold* is that they do not retreat into a thought experiment without human beings. Instead, they describe natural history as it is currently, that is, as being affected by a specific and differentiated human history. This blending of different human stories and different natural stories, distinct state-supported capitalisms and distinct environmental losses, is the work that remains to be done.

We will have to come up with new names that describe these practices, as well as new names for resisting them that bring these ways of life and thought to an end. Donna Haraway reminds us, for example, that there are emancipatory possibilities for naming, too—ones that narrate or describe the kind of multispecies approach that we must adopt if we are to begin to end the Anthropocene. "I propose a name," writes Donna Haraway; "the Chthulucene," a name for "earthly worlding."[58] "Unlike either the Anthropocene or the Capitalocene," she writes, "the Chthulucene is made up of ongoing multispecies stories . . . in which the world is not finished and the sky has not fallen—yet."[59] This is, in a certain sense, the aim of the work, and the work that I will take up in the final chapter on politics and in the conclusion of the book. There I propose a new framework for a posthuman assembly, whereby it would be possible for other species and the planet to appear in public space.

2 ART: THE TRANSITION FROM POSTMODERN ART TO THE ANTHROPOCENE

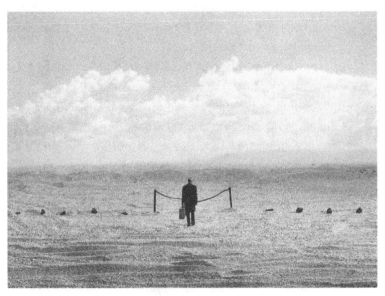

FIGURE I. Gilbert Garcin, *L'interdiction*, 2000. Gelatin silver print (photo: Stephen Bulger Gallery). © Gilbert Garcin.

THE TALLEST CLOUD AT THE END
OF "MAN"

The "storm of the century." Again. Another "hottest year on record." By now increasingly violent weather is everywhere and all around us, swinging back at us like a pendulum.[1] Along with the melting of the earth's polar ice caps, mass extinctions, droughts, fires, and other changes to the Earth's atmosphere, there is broad scientific agreement that storms, typhoons, and hurricanes will continue to become more intense, more frequent, and more catastrophic in the coming years.[2] Meanwhile, on the rooftop of a trendy hotel in New York City, visitors live-forecast the weather through an art installation that takes inspiration from the 1996 blockbuster *Twister*. At the 2020 Armory Show, the artist Tezi Gabunia simulates the flooding of the Louvre—an archive of civilizations under water—based on the Paris floods of 2018. Elsewhere, a chunk of glacial ice melts outside the Tate Modern. It has been placed there by the artist Olafur Eliasson, who is known for another installation at the museum, *The Weather Project*.

This chapter will explore the possibility of a new kind of art and narrative in the era of the so-called Anthropocene. To do this, I follow a series of contemporary works of art that depict strange or more violent weather. In attempting to inherit the word *Anthropocene*, my interest in these works of art is the story that they tell of *anthrōpoi*: these artworks collectivize and historicize human beings

in the face of catastrophic elements, as though "man would be erased," as Michel Foucault put it, "like a face drawn in sand at the edge of the sea."[3] This encounter with the elements does not invite us, as certain Romantics did, to reflect on our inner selves, our personal attachments, or our own moral sentiments. Instead, it asks the reader or viewer to reflect on the geological effect of our species across deep time. These works are also entirely contemporary: they depart from any sense of a pure "nature" and extend decades of art and thought that critiqued the privilege of humanism and the art of interior human life (Duchamp's "Fountain," Barthes's "death of the author," etc.). And yet they inhibit the art of inner life not through creative practices like facsimile or collaboration alone, but through a certain, distorted exposure to the elements. My wish in this chapter is to say as plainly as possible that I think we are witnessing a sea change in our imaginaries as a result. When confronted with say, storm clouds, in a work of art today, it is as though culture and thought are once again passing "beyond man and humanism," as Derrida said, albeit in a different way—not just "in the . . . terrifying form of monstrosity" of something like threatening weather, but in a different kind of catastrophe that feels collective and collectivizing.[4] As I will show, these shared stories of catastrophe due to climate change are contributing to a certain reinvention of epic in our time. This epic of human beings and catastrophic elements—a narrative that challenges and discredits our collective human reason instead of

refines or exalts it—is what I would like to call the tallest cloud at the end of "man."

Consider two very different encounters with storm clouds.

The first is exemplified by Immanuel Kant's 1790 description of "thunderclouds piling up in the sky" and humans' "superiority" over them.[5] In his discussion of the experience of the sublime in nature, Kant famously writes in *The Critique of Judgment* of "thunderclouds piling up in the sky and moving about accompanied by lightning and thunderclaps . . . hurricanes with all the devastation they leave behind, the boundless ocean heaved up."[6] The later Kant, like many of his fellow Romantics, tells us that such experiences of weather "raise the soul's fortitude" so that "we could be a match for nature's seeming omnipotence."[7] For

> although we [initially] found our own limitation when we considered the immensity of nature . . . we also found, in our power of reason, a different and nonsensible standard that has this infinity itself under it . . . we found in our mind a superiority over nature itself in its immensity . . . a superiority over nature that is the basis of a self-preservation quite different in kind from the one that can be assailed and endangered by nature outside of us.[8]

Now consider a second type of phenomena that more aptly describes our present age. At the Montreal Museum of Fine Arts, one encounters a 2012 installation by Sarah Anne Johnson—an acclaimed work in the museum's contemporary collection (see figure 2).

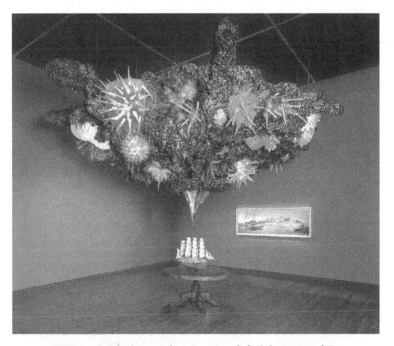

FIGURE 2. Sarah Anne Johnson, *Untitled (Schooner and Fireworks)*, 2012. Expanded polyurethane foam, plastics, LED lights, stove paint, acrylic paint, wood, balsa, cotton canvas and string, silicone resin (photo: Montreal Museum of Fine Art), https://www.mbam.qc.ca/en/acquisitions/sarah-anne-johnson/.

Johnson's untitled piece arose from her residence on a ship in the melting glaciers of the Arctic. The installation depicts a centuries-old, almost colonial-era ship beneath a large coral- and jellyfish-laden storm cloud. The museum curators describe the cloud above as

an immense dark and coloured structure, like a multi-coloured storm cloud. Within this mass may be seen glasses,

dishes, heat-moulded structures in which brightly coloured lights appear, producing various bursting and sparkling effects. This cloud, both fantastic and worrying, could remind oneself of fireworks or a tornado, and seems to descend almost as far as the schooner.[9]

Johnson's storm cloud surrounds the vessel below as if to devour it, yet her approach is very different from Kant's approach above. Whereas Kant calls thunderclouds *sublime* since "we are in a safe place," Johnson's piece finds no safe refuge from them.[10] We are out at sea, after all. Our ship, a symbol of the technological apparatus of colonialism and early free trade, is no match for the ominous storm cloud above it. The installation suspends us in the moment before disaster strikes, standing before a contaminated, polyurethane storm cloud—one that evades any human ability to master it.[11]

What kind of art is being made in this new era? Here, I begin by examining a contemporary play in which human survival depends on the weather. As we will we see, this play becomes a metafiction about the reinvention of epic itself. Based on a brief review of similar contemporary works of art, I outline some aesthetic practices in contemporary art that might mark an approach to art in the Anthropocene. I conclude with a genealogy of clouds that depicts a shifting relationship between humans and nature in the art and thought of Aristophanes, Wordsworth, Plato, Heidegger, and others. What follows, ultimately, is a reflection on different ways of looking at clouds or weather. This reflection passes from postmodern

ways of seeing and creating to ways of seeing and creating that seem exemplary of an Anthropocene. It then sets this contemporary approach against the backdrop of some other, earlier approaches to thinking about clouds.

FROM POSTMODERN CREATIVE PRACTICES TO A NEW AESTHETICS OF THE ANTHROPOCENE IN ANNE WASHBURN'S *MR. BURNS*

My interest in the contemporary works of art that we will discuss is the production of a new kind of aesthetics—a new encounter with the elements—that is not only retreating from humanism, individualism, and interior life like contemporary artists before them, but introducing the idea of human beings as a collective and historical epoch in geological time. It appears that what is being explored or narrated by these artists is the end of a certain relationship between humans and the rest of the earth. These works of art announce an era in which, at least genealogically and collectively, humans do not live in concord with the rest of the earth anymore.

Anne Washburn's celebrated 2012 play, *Mr. Burns, A Post-Electric Play*, is an example of what this aesthetic might look like in practice.[12] Washburn's play about the end of the world begins in media res with survivors fleeing a nuclear disaster in the era of climate change. In the first act, we learn that what initially began as a failure of the electric grid resulted in the loss of power to cooling

rods in nuclear power plants. We are not sure of the extent of the disaster, but it feels like the end of the world is near. As the play opens, we are waiting for air to carry nuclear radiation to survivors fleeing cities. Whether the characters in the play are safe now "depends on the weather. On the wind," says one survivor.[13]

The opening scene of Washburn's play is set, strangely, in the pastoral—a forest in Massachusetts—that is at least fifty miles from any major city. The group of survivors cool beer together in a nearby stream and warm themselves around a makeshift fire in the woods. Yet these are the last vestiges of nature that we hear about in the play. A kind of juxtaposition is being set up between the elements and human beings. Soon after this, the world of Mr. Burns feels entirely one of human construction and technology. It is a world that is no longer habitable in the same way.

Those who survive the traveling nuclear clouds are decidedly unintrospective and unconcerned with inner life. Instead, they try to remember a familiar story together about Homer (Simpson, that is), which they all seem to know despite being from different places. This attempt at collective memory takes their mind off imminent disaster.[14] It invites the audience to reflect on the idea of the invention of epic (as opposed to lyric or drama), as characters remember and retell a well-known pop narrative together after the fall of civilization.[15]

What these friends talk about or attempt to remember is a *pastiche* of a *pop culture* narrative, namely a Simpsons

episode. Yet this particular Simpsons episode, "Cape Feare," is an interesting choice, since this episode is actually a parody of a 1991 film directed by Martin Scorsese, *Cape Fear*.[16] This makes the play not only a work of art about another work of art, but a work of art about a work of art (a Simpsons episode) that is about yet another work of art (a 1991 film by Martin Scorsese).

The play is not only a copy of a copy of a work of art. It is a *metafiction* about the invention and reinvention of epic. Washburn holds up a mirror to the human epoch itself. She dates this epoch at the time of Homer and the time of Homer Simpson. She sets it in the first capital of the new American colony, a major post for the North American slave trade, the hub of global capital, the site where George Washington was first sworn in, and so on. This setting simultaneously marks the time of various events and invites us to reflect on time, history, and genealogy.

It should also be noted that there is something "postmodern," for lack of a better term, about Washburn's creative process. Instead of crafting the story from out of her own "genius," she chose to begin the play by writing down or appropriating a conversation that she had with friends about a Simpsons episode.[17] This conversation originally took place in an old banker's vault beneath Wall Street.[18] The first lines of Washburn's play are nearly a word-for-word transcription of the conversation that took place among friends underneath Wall Street.[19]

In the end, Washburn's *Mr. Burns* is one approach to art in the Anthropocene. The play takes place "after the

fall of civilization."[20] The end of the world is felt—
together with the rest of the audience. Rather than sur-
mounting nature through one's reason as Kant had once
imagined, the survival of human civilization depends on
the *weather* itself. In a story about the reinvention of epic,
this is a very interesting choice: after all, the weather is
one of the first things humans talk about with one another
or share. The survivors' fate is up to the direction of the
winds or clouds that carry the nuclear radiation from
power plants whose generators have failed. That old, Pro-
methean push of human knowledge, technology, and
mastery over the elements is here a pendulum that swings
back at human beings. The play forces us to consider the
story that we might tell about human activity on Earth. It
asks the audience if humans would do it all over again in
the same way if they were given the chance. Washburn's
answer to this question is yes. We would.[21]

FROM POSTMODERN ART TO THE ANTHROPOCENE: FIVE POSSIBLE PRACTICES FOR ART AND THOUGHT IN THE ANTHROPOCENE

The art of the Anthropocene can and will take many
forms. Here, my primary interest in works of art like
Johnson's or Washburn's is the narrative they tell: they col-
lectivize and historicize human beings as a species threat-
ened by catastrophic elements. Instead of Atlas holding

up the sky, the sky is advancing upon us. Instead of returning to an idyllic state of nature in the manner of Rousseau, we are fleeing from nature's disastrous advances. There is no triumph over these elements by virtue of enlightened human understanding or scientific progress. Instead, we are living in the face of what Kant once called nature's "might," but suspended in the moment before, according to Facebook, we can be "marked safe." What we experience, through nature, is more than a single human being's finite limitation. We encounter the end of the world in a phenomenological sense as Arendt explained it: the end of a "man-made world" that "can quite literally endure throughout time until mankind itself has come to an end."[22]

These contemporary works of art immerse us in an epic, as opposed to a lyric. They also depart from any sense of a pure "nature." Simultaneously, they pass through what Roland Barthes observed in the 1960s as the "death of the author": they employ practices like collaboration, facsimile, collage, constraint, and so on to displace a kind of art in which "the voice of . . . the author ['confides'] in us."[23] As Foucault put it, these so-called postmodern creative practices were ones "in which I can lose myself."[24] And yet here, it is almost as though Foucault's "man" were being erased, as he concluded in *The Order of Things*, like a face drawn in sand at the edge of the sea—that is, an "I" that is being erased, in part, by catastrophic elements.

My effort is not to suggest that any type of art or creative process is or should be universal, but merely to begin to translate some contemporary art into more discursive and critical modes of thought in an attempt to think about what it is that we are doing, what rituals we are performing, and what narratives we are telling one another. The following explores five particular themes in contemporary art as they relate to the art of a so-called Anthropocene.

The End of the "World"

Contemporary art is constantly staging and rehearsing the end of the world in the face of catastrophic elements.[25] Harland Miller's etching at the 2017 Armory Show in New York City sums up the sentiment comedically: "ARMAGEDDON: IS IT TOO MUCH TO ASK?" Novels like Ben Lerner's *10:04* (2014) or Andrew Durbin's *MacArthur Park* (2017), for example, take place in the time of unlikely and devastating urban storms. Films like *Annihilation* (2018) or *Melancholia* (2011) are set in a temporality of *anticipating* a natural disaster that will affect or extinguish the way of life before it. Works like these allow audiences to realize or experience a newfound exposure to natural or unnatural catastrophe, or imagine how the world might look different before or after human life itself. In the end, author Andrew Durbin says that his work about a hurricane hitting a major city and its aftermath is an attempt to consider "an emancipatory politics

that might emerge from the ecological wreckage of our moment as . . . opposition to the current economic configuration of 'the world.'"[26]

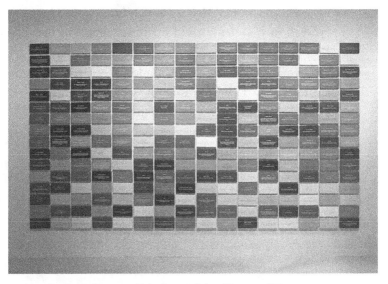

FIGURE 3. Octavio Abúndez, *A Select History of Humanity*, 2019 Acrylic paint on canvas (256 paintings) 101 1/5 × 177 1/5 × 1 1/5 in. Galería CURRO.

Deep Time and Genealogy

There has been a renewed interest in history or deep time in contemporary works of art. Octavio Abúndez's *A Select History of Humanity* (figure 3) is a series of notecard-like placards that records events throughout geological and human history, such as "The Sun forms—4,567,000,000 BC,"

"circa 25,000 BC—Age of the oldest found permanent human settlement," or "589 AD—First reference to the use of toilet paper in China." Each placard tells of a different event in geological and human history—transitional events or "spikes" that mark significant events for the planet, such as the birth of the steam engine or the invention of the nuclear weapon. In another work, "A Fake History of Humanity," Abúndez tells a story of our species with false information, seemingly underscoring the importance of the archive. It should be noted that Abúndez's creative process uses appropriation like Washburn's above: the color and design of the placards are actually based on and appear to viewers to be copies of the German artist Gerhard Richter's Color Charts. This indicates to us that the artist did not conceive of the work as an original work of art out of the artist's own mind or genius, but by mimicking, copying, or collaborating.

After the Romantics

Many artists are looking to the elements today in a different way than those before them. An anthology of literature that describes a twenty-first century approach to nature—the "postmodern pastoral"—attempts to mark this turn.[27] These artists do not entertain a pure vision of "nature," which incidentally no longer even exists for them as a concept. For example, Sarah Anne Johnson's storm cloud discussed earlier portrays a mélange of

weather and human-made chemicals (fireworks above the Arctic); it is composed of polyurethane foam, plastics, and LED lights; and it is modeled after a *copy* or photograph, and not directly on nature. This indicates a certain departure from something like Monet's process of setting up an easel in a field and directly observing the way light fell on haystacks.

Here, the elements are not inferior to human beings and in need of cultivation, nor are they separate from them, superior to them, or transcendental. They are, in a certain way, a product or child of human beings. But they are, if anything, antithetical to them. It is as though a tidal wave, full of plastic, crashed down upon a city of human beings, even those who were not primarily responsible. This contaminated "nature," which threatens human existence instead of attuning it or serving the human subject's purpose in the end, might be called "postromantic" if we begin to understand this term as a kind of discord in our experience with the elements rather than a "reciprocity" with nature. The age of—and hope for—human "reciprocity" with nature, thought of culturally as "Romantic" (i.e. Wordsworth, Hölderlin, etc.) and envisioned by geologists as a "Holocene," is over, at least collectively. The contemporary photographs of Edward Burtynsky, for example, seem to mark a departure from works that imagine a more ecological or Buddhist relationship to nature in the way of Merce Cunningham's nature studies or Robert Smithson's or Andy Goldsworthy's installations might.[28]

These "postromantic" artworks do not ultimately worry about our own individual existence before the elements. As Isabelle Stengers writes, when it comes to nature, "The case is new. Gaia, *she who intrudes*, asks nothing of *us*, not even a response to the question she imposes."[29] Instead, these works concern themselves with humankind's disastrous effects on earth and collectivize our death.[30] In Gilbert Garcin's photos, for example, we are forced to confront a discord between humans and the earth whereby the earth is depicted as a looming threat to human life as such.[31] Human achievement stands before nature exposed, unsafe, ultimately unable to find safe harbor from the storm.

The New Death of the Author

Twentieth-century techniques like copying, appropriation, collage, collaboration, juxtaposition, or the use of various constraints once critiqued the privileging of the subjective life of an author and ensured that works of art would be more than, say, an expression of the inner life of Tchaikovsky.[32] These techniques took place in a time after Proust; they were attempts, as Deleuze and Guattari might put it, "to reach . . . the point where it is no longer of any importance whether one says I."[33] As postmodern techniques like copying, appropriation, or collage continue to be used, they also work to ensure the separation—the lack of any transcendent connection—between the author and nature that was characteristic of certain Romantics. This is seen, for example, in Cory Arcangel's *Super Mario Clouds* (see figure 4) or in Eduardo Coimbra's

Natural Light. Another way of reading these works is that they depict dystopian human attempts at geoengineering—that is, attempts to create a synthetic experience of a nature that is peaceful and calm and contrary to the everyday phenomena of climate change. In other cases, the elements wipe out humanity as such through a catastrophic event.

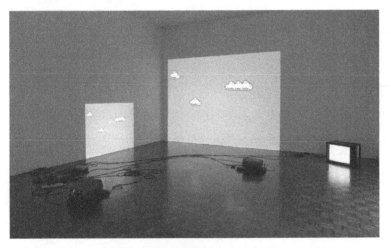

FIGURE 4. Cory Arcangel, *Super Mario Clouds*, 2002. Handmade hacked Super Mario Brothers cartridge and Nintendo NES video game system. Cory Arcangel, http://collection.whitney .org/object/20588.

The Reinvention of Epic

Abúndez's or Johnson's work is defined by a certain type of poetics: not the lyric or drama, but an epic. Abúndez's work presents a "a select history of humanity." Johnson's

installation depicting a ship in the Arctic does not seem to ask us to consider a single contemporary voyage; it appears to invite us to consider maritime endeavors over a swath of time from perhaps colonialism, early free trade, or the slave trade up until climate change. Likewise, Anne Washburn's play *Mr. Burns* reimagines epic in order to reflect on our species across deep time. It invites us to reflect on a story that we might tell about human beings or human civilization as such. There is no universal or master narrative to be told here, but there is also no lyric or dramatic escape from this story. The author does not send individually self-conscious, reflective, existential, or morally responsible protagonists to leap over an abyss one by one, to frolic in a pristine river where nature loves our protagonist and our protagonist treats nature differently. Instead, the story seems to be about an era of human beings as such that is folded into geological time. It matters very much that we are telling these kinds of stories.

In *The Postmodern Condition*, Jean-François Lyotard described postmodernity as the absence of grand narratives and a turn to little narratives or *petits récits*. "We no longer have recourse to grand narratives" or epic in contemporary society, wrote Lyotard.[34] "The grand narrative has lost its credibility, regardless of what mode of unification it uses," and "the little narrative [*petit récit*] remains the quintessential form of imaginative invention" in our time.[35] The postmodern duty or "Answer," as Lyotard put it, was to "wage a war on totality."[36] By contrast, many contemporary works of art suggest a *certain* shift beyond postmodernity and a

certain reinvention of epic narrative in our time. These new grand narratives describe an entire species up against a catastrophic encounter with the elements. To be clear, this narrative form does not return us to a universal "world history," a dialectic of Spirit, or a "people" with a "historic mission," as Lyotard worried openly about Heidegger's 1933 address in *The Postmodern Condition*.[37] This new narrative form "about the state of the sky and the flora and the fauna" is a kind of grand narrative that actually *destabilizes* knowledge and society via instances of *catastrophe* without consensus.[38] Just as Abúndez's select history above does not claim to be universal, I have argued that this new epic is necessarily differentiated and local.

A GENEALOGY OF CLOUDS FROM EARLY GREEK THOUGHT TO HEIDEGGER

Studying ways of looking at the weather seems especially instructive at this moment, as if it were a prescient map for refining our own approach to clouds in the Anthropocene. Below, I briefly consider some different ways of looking at clouds that are recorded in the art and thought of the Presocratics, Aristophanes, Plato, Nietzsche, Kant, Wordsworth, Shelley, Hölderlin, and Heidegger. As we noted in chapter 1, human exceptionalism is neither distinctly Modern nor European. To be clear, then, this is one genealogy among many. We require multiple genealogies about human beings' relation to nature and multiple stories of resistance.

Throughout the period of the Holocene, human civilizations were able to flourish for thousands of years in a relatively stable relationship with the climate. Meanwhile, Nietzsche tells us that in much of archaic art, it made no sense to speak about a separation between humans and nonhumans; there was an "original oneness with nature."[39] This lack of distinction between humans and nonhumans is depicted in various vase paintings or in the ancient Greek word for tragedy, *tragōdia*, which refers literally to a goat song, or to those who danced in costumes as if they were animals as they imbibed the fruits of the land. We find a similar view throughout much of early Greek thinking, whereby water, air, fire, and earth are one and the same with the soul.[40]

What Nietzsche details in his genealogy of tragedy, however, is well known: a separation between humans and nature begins to form over time, and a hierarchy between nature and humans also begins to develop.[41] Starting with the Greek festival, Nietzsche writes, it is as though "nature were bemoaning the fact of her fragmentation, her decomposition into separate individuals."[42]

We find records of humans' distance from nature or triumph over it in passages like Sophocles's famous and somewhat ironic "Ode to Man" in *Antigone*, in which the chorus breaks out cheerfully about humans' mastery and power over the earth, animals, the sea, and yes, *weather*. "[Man] conquers all," declares the chorus; "terrible wonders walk the world but none the match for man."[43] Man not only snares the bird, tames the stallion, and domesti-

cates the fiery bull; he creates "shelter . . . under the cold clear sky and the shafts of lashing rain."[44]

As humans lost their primordial connection to nature, according to Nietzsche, a new humanism crystallized in the figures of Euripides and Socrates. For example, we know that the historical Socrates was not only famous for his practice of philosophy in Athens, but in particular for Aristophanes's depiction of him in *The Clouds* (423 BCE). In fact, according to Plato in *The Apology*, and particularly in Diogenes's account of Socrates's life, what came to mind when the name Socrates was uttered was most often Aristophanes's representation of Socrates in *The Clouds*.[45]

Aristophanes's play depicts Socrates attempting to study the clouds and converse with them, or "associate in speech with the Clouds."[46] On some days, the conversation goes, the clouds take the shape of animals, but today, on the day when Strepsiades meets Socrates, the clouds resemble human beings.[47]

The clouds in Aristophanes's play are not exactly women or humans themselves, explains Socrates, but they are "like women."[48] Socrates later uses the word *homoios* to describe how humans are like or similar to clouds.[49] Oh, says the eager Strepsiades, so they are just like "when I crap, it absolutely thunders . . . just like [the clouds]."[50] Socrates agrees with this assessment. And lightning, he adds, is like when wind gets caught in the clouds and the cloud "bursts . . . like a bladder."[51]

Still, Socrates is up to something more. He is attempting to discover humans' capacity for *logos* in the unique

act of observing nature. When Socrates explains to Strepsiades what he has done in looking at the clouds, he says that he has "suspended the intellect (*noēma*), and mixed the thought in a subtle form (*tēn phrontida leptēn*) with its kindred (*homoios*) air."[52] In other words, not only has Socrates experienced a limitation of his intellect when looking at the clouds; he was then able to think in a different and more refined way as a result of observing the clouds.

The Greek word used to describe this second type of thinking or thought, *leptos*, has both the sense of quality insofar as it is subtle or more refined, and also the sense of quantity insofar as it is smaller, lesser, or weaker.[53] In this way, Socrates declares, the clouds are the source of all of our judgment or means of knowing (*gnōmē*).[54] This passage is, of course, remarkably similar to the way Kant describes storm clouds in *The Critique of Judgment*.

However, we can mark a distinct *separation* and the formation of a *hierarchy* between clouds and *anthrōpoi* in the Socrates of Plato's *Republic*. In the discussion about musical education in Book III, Socrates attempts to prohibit the kind of drama in which someone "gives a speech as though he were someone else."[55] Yet here, very curiously, Socrates says that he is particularly concerned about someone acting as if they were "thunder, the noises of winds, hailstorms,"[56] "the roaring of rivers, the crashing of the sea . . . everything of the sort."[57] An important thing about nature is imparted here: good men should

not act like or pretend to be like weather, as they are of a *different*, calculating sort and *superior* to nature.

The return to nature by Kant or other Romantics was supposed to mean that humans and nature would be "reconciled" once more and at long last, thus overturning the legacy of Plato's metaphysics. But here again, the way that "man" perceived nature quickly became as important or even more important than nature itself. In "Mont Blanc," for example, Percy Shelley studies nature so that "man may be . . . with Nature reconcil'd," but ultimately for the sake of "the human mind's imaginings," that is, to see in nature "the source of human thought." Likewise, in "Tintern Abbey," Wordsworth explains that he "has learned to look on nature" in order to experience "elevated thoughts," for "in nature" one finds "the anchor of [his] purest thoughts," "thoughts of a more deep seclusion." Although these works turn outwards towards "nature," it is a nature that is ultimately for us.

Hölderlin, as well, pursues a "more deep seclusion" in his encounter with the sky: "My love and my sorrow melt into light and air! . . . and lonely / Under the heavens I stand as always."[58] In each case, human reason is refined in the experience of witnessing nature; yet nature always serves the superior emotion or intellect of a human being. What matters, ultimately, is not nature itself, but the way the human being perceives nature—the thought that human beings arrive at through their experience of looking on nature.

Another way to describe the problem of aesthetics until this point is that there always exists what the French philosopher Quentin Meillassoux calls *correlationism* with respect to humans and nature. Correlationism, Meillassoux writes, is "the idea according to which we only ever have access to the correlation between thinking and being, and never to either term considered apart from the other."[59] To put it more simply, for Meillassoux there has been a failure since Kant to consider objects independently of ourselves, or outside of a kind of anthropomorphic, humanistic, or subject-oriented perspective. This is a result of the famous "Copernican Revolution" of Kant's critical thought, whereby it is not the object itself that matters, but the way in which the subject perceives that object. The consequence of this subject- and human-oriented way of thinking, for Meillassoux, is that philosophers since Kant have been unable to consider objects outside of any human relationship to them.[60] As Meillassoux writes:

> Contemporary philosophers have lost the great outdoors, the absolute outside of pre-critical thinkers: that outside which was not relative to us . . . existing in itself regardless of whether we are thinking of it or not; that outside which thought could explore with the legitimate feeling of being on foreign territory—of being entirely elsewhere.[61]

Meillassoux's project, then, is to consider how objects could be thought separately or independently from human subjects. I do not wish to follow Meillassoux in this project due to reasons I describe in the introduction.

Still, what is very interesting to me, in view of Meillas-soux's critique of correlationism, is the difference between something like Hölderlin's encounter with weather, which is characterized by a "reciprocity" between nature and humans, and Heidegger's initial reading of Hölderlin's encounter with weather in his 1934–35 lecture course, which is characterized by a kind of exposure to and discord with the elements.[62]

While Hölderlin speaks of a new "reciprocity" between nature and humans, Heidegger tells us that this "new unity [between nature and humans] is comprehended as dissolving itself."[63] Likewise, when Hölderlin tells us that "the holy cloud is hovering around a man," Heidegger says that when the poet "stands 'under God's thunder-storms,'" he does so "left without protection and delivered from himself."[64] In other words, instead of describing a reciprocity and harmony between human beings and nature, or a way of arriving at one's deeper or true self through the experience of nature, Heidegger attempts to mark a discordance between nature and human beings—one without safe harbor—in humans' encounter with violent weather. It is as though Heidegger wants to rewrite the very section on weather and humans' "superiority over nature" in Kant's *Critique of Judgment* by telling us that humans cannot find safe harbor from nature through their own superior reason.

Notice in another passage, for example, how Heidegger takes a stance *against* Hölderlin's "reciprocity"

between thunderstorms and human self-consciousness as he continues in the next line:

> When Hölderlin speaks of the "poet's soul," this does not refer to some rummaging around in the lived experiences of one's own psyche, or to a nexus of lived experiences somewhere inside, but signifies the most extreme outside of a naked exposure to the thunderstorms.[65]

What does Heidegger mean by this "naked exposure to thunderstorms"? What is this exposure to violent weather?[66] Why can't this exposure to violent weather be reduced to the psyche and how exactly does it threaten "man"? Heidegger is on the cusp of considering a critique of humanism through the experience of violent weather, or what I would like to call the tallest cloud at the end of man. As Foucault wrote, "One can certainly wager that man would be erased [*s'effacerait*], like a face drawn in sand at the edge of the sea."[67]

CONCLUSION: A FACE AT THE EDGE OF THE SEA

As we transition into the so-called Anthropocene, a new kind of art is responding to the experience of more violent weather due to climate change and narrating an epic about humankind. In short, something has changed in the way artists and writers reflect on the elements today. These elements are distorted, terrifying, and even geoengineered or synthetic. They threaten us collectively in a

new era of history. They fold human history into a geological timescale, and they invite us to think about our species' effects on the earth. Rather than finding a sublime refuge from the elements or in their midst, we have a sense that, due to these contaminated elements, humankind could be washed away like a face drawn in the sand at the edge of the sea. Similar ruminations take place in the minds of all sorts of people when confronted viscerally with increasingly violent weather due to climate change—including those who deny the scientific facts of climate change, and those who are primarily responsible for it. In fact, strange weather is the most common story about climate change that we are telling one another. And this story transitions us away from many of the narratives, practices, and presumptions that are most responsible for climate change. To what extent is the basis of climate change (and contemporary capitalism) destroying itself when these kinds of stories are told and shared together? Perhaps in a similar way that Heidegger once described the call of conscience as coming *from* me and yet from *beyond* me or *over* me, we encounter these elements, through strange weather, like a pendulum that was set into motion by human beings, but one that now swings back at us with its own force.[68]

3 POLITICS: DEMOCRACY AT THE END OF THE WORLD

The only thing in the world that's worth beginning:
The End of the World, no less.

> —*Aimé Césaire, Return to My Native Land*[1]

Worldlessness as a political phenomenon is possible
only on the assumption that the world will not last.

> —*Hannah Arendt, The Human Condition*[2]

TO BEGIN THE END OF THE WORLD: ON W.E.B. DU BOIS'S "THE COMET"

In June of 2020, in the midst of a global pandemic and Black Lives Matter protests in the US and elsewhere, Saidiya Hartman drew attention to W.E.B. Du Bois's "The Comet," a speculative short story about the end of the world.[3] Composed after the 1918 flu pandemic, and also after the Red Summer of 1919, in which people of color in the US experienced extensive White supremacist

terrorism and violence, Du Bois's "The Comet" appears as the final chapter of his 1920 book *Darkwater*. Like the site where Anne Washburn's play *Mr. Burns* began to be written, Du Bois's story is set initially in an old banker's vault beneath Wall Street. In Du Bois's story, as with Washburn's play, the end of the world is due to a traveling cloud of gas or toxic air. Both narratives speculate about toxic clouds at the end of the world.

What makes Du Bois's "The Comet" entirely distinct from Washburn's play is that Du Bois's story about the end of the world is a deep meditation on race. Up until a comet sweeps past the earth and kills every other known person with its toxic gas, the lone survivor, a Black man named Jim Davis, is described as having been "outside the world" or "under the world," but never in it.[4] Nor has Jim ever been considered "human" due to "human distinctions."[5] "I was not—human, yesterday," he says, referring to the day before the end of the world.[6] Then one day, when Jim Davis returns upstairs after working in an old, subterranean bank vault beneath Wall Street, he finds everyone dead. His eyes pan to a newspaper story about a comet with deadly gases sweeping past the earth. It is the fact that "the world is dead," he says, that makes him human for the first time.[7]

Earlier in *Darkwater*, Du Bois famously defines Whiteness as the "ownership of the earth forever and ever."[8] In the book's final moments, Du Bois considers whether the end of the (White) world would allow Blackness to exist or be seen. The prospect of human extinction in "The

Comet" permits Du Bois to imagine that another world is possible. For the first time ever, Du Bois's Black character Jim Davis enjoys a sense of humanity and freedom in the streets of New York City. He embraces death, too; he calls it "the leveler."[9] Sometime later, Jim finds one other survivor, a wealthy White woman named Julia. They consider it plausible that they are the only two people alive on earth. Due to Julia's presence in the story, the Black narrator, Jim, gets to bear witness to the end of the White world, too. Julia is described as "calling to the world" over and over, and hearing only silence.[10] Jim observes this closely. While Jim's world is perhaps just beginning, Julia's White world is gone.

What is this world, then, that is ending? It isn't the world in the Americas that, from the years of 1492 to 1650, saw its population decrease from around sixty million to six million as a result of European invasion, genocide, and colonialization.[11] As Lawrence Gross writes, "Native Americans have [already] seen the ends of their respective worlds."[12] Nor is it the "world-destroying" moment, as Saidiya Harman describes it in *Scenes of Subjection*, when Frederick Douglass witnessed the beating of his Aunt Hester.[13] It is not the world of Fanon, who wrote famously of colonized land as a "world divided into two . . . inhabited by different species," nor is it the world of Baldwin, who remembered Job as being "chased out of the world" before Coates wrote *Between the World and Me*.[14] Rather, it is the prospect of the end of a world

that has excluded or ended other worlds. It is the possibility of extinction for those who determined who was human. As Kathyrn Yusoff writes, "The Anthropocene might seem to offer a dystopic future that laments the end of the world, but imperialism and ongoing (settler) colonialisms have been ending worlds for as long as they have been in existence."[15]

Before any political remedies for the Anthropocene are proposed, then, one first has to listen to Du Bois's dystopian imaginary in "The Comet," or Aimé Césaire's wish when he writes, "I must begin. . . . The only thing in the world that's worth beginning: / The End of the World, no less."[16] And yet, as Kathyrn Yusoff concludes in *A Billion Black Anthropocenes or None*, it is necessary to work both "*for the end of this world* and the possibility of others."[17] It is possible to respond to this new era of climate change with greater inequality, war, or allowing the most vulnerable to suffer without aid or migration. But is it also possible to imagine the creation of more equitable worlds? Could the Anthropocene collectivize us and politicize us into something more than neoliberalism's culture of the self, and something less than entrenched borders and national identities? Because in addition to ending this world, a new political project must commence. And soon. Below, I make a case below for a new kind of ecological democracy at the end or limits of the world and conclude with how this might be achieved.

THE ANTHROPOCENE AS A CAPITALOCENE

The worlds that must be ended were not constructed by an entire species uniformly or brought about by *anthrōpoi* in general. They were created by historical, political, and intellectual apparatuses and processes involving the exercise of power and the subjugation of others and nonhumans. At the same time, it would be foolish to downplay the fact that the increasing population of our species is one of the largest accelerators of climate change. To begin to end these worlds, then, one would need sophisticated methods for reading history and politics in both collective and differentiated ways, and one would need to endeavor to deconstruct the underlying philosophies and narrative systems that guide these destructive ways of life. It is only out of this deep intellectual and cultural work that new political projects can commence.

Since the Anthropocene is a multiplicity and not a universal, this work requires the development of multiple genealogies and counternarratives that do not presume to be universal. To begin with, one must attribute the Anthropocene to more specific names and histories that differentiate *anthrōpoi* accordingly, such as: an Anglocene, whereby the United States and Great Britain made up almost 50 percent of all emissions as recently as 1980; an Oliganthropocene, or a geological epoch that is actually the result of a small fraction of disproportionate polluters, the very wealthy; a Plantationocene, or the growth

of race-based coercive labor and its method of extraction from the 1600s on; a Thanatocene, where war and the military industrial complex has contributed immensely to emissions; a Eurocene, an antagonistic relationship with the environment and the rest of the world that stems from European thought and practice; a Techno-cene, Misanthropocene, *Man*thropocene, and so on.[18] Still, Donna Haraway has argued that if we could have only one name for the historical configuration that gave birth to the Anthropocene, it would be a Capitalocene, where the pursuit of private profit has amounted to the financialization of the very deconstruction of the planet.[19]

As Jason Moore explains in *Anthropocene or Capitalocene?*, "The Anthropocene sounds the alarm—and what an alarm it is! But it cannot explain how these alarming changes came about."[20] "[T]he Capitalocene," by contrast, "signifies capitalism as a way of organizing nature—as a multispecies, situated, capitalist world-ecology."[21] As Christophe Bonneuil and Jean-Baptiste Fressoz put it,

> To speak of a "Capitalocene" signals that the Anthropocene did not arise fully armed from the brain of James Watt, the steam engine and coal, but rather from a long historical process of economic exploitation of human beings and the world, going back to the sixteenth century and making industrialization possible.[22]

The most immediate historical shift that made this industrialization possible in Europe, at least, was a new transatlantic trade. What was being traded were actual

slaves, as well as goods and value produced by slave labor (sugar, cotton, gold, silver, copper, and so on). The first voyage of the transatlantic slave trade took place on Columbus's second voyage to the New World in 1493; by 1510, the systematic transportation of African slaves commences across the Atlantic.[23] This period is consistent with the well-known sharp decline of the indigenous populations in the Americas. By contrast, the White population in North America grew from 300,000 in 1700 to 6 million in 1800. The use of coal, "the fuel of British hegemony," takes off and is exported globally.[24] By 1825, Great Britain is responsible by 80 percent of global emissions.[25]

Still, if the historical processes of the Capitalocene are largely responsible for the genesis of the Anthropocene, then contemporary Capitalocenes have to be understood according to their own unique historical processes. Since the 1970s, philosophers and political theorists have emphasized, in this respect, a contemporary mode of state-supported capitalism called *neoliberalism*—a distinct, historical mutation of capitalism in the 1970s and 1980s in which the state actively supports the free market.[26] While much of the recent scholarship on neoliberalism has focused on its undermining of democracy and political representation, what has not been discussed enough in that scholarship are the ways in which neoliberal policies directly support the global fossil fuel infrastructure and finance the destruction of the planet.[27]

Michel Foucault developed the term *neoliberalism* in a 1979 lecture course at the Collége de France to refer to a

contemporary mode of capitalism and thought that considers the primary concern of the state to be aiding financial markets.[28] Unlike laissez-faire capitalism of the eighteenth or nineteenth centuries—a "leave us alone" approach in which the state does not interfere with private, financial markets—neoliberalism is a "positive liberalism" or "intervening liberalism," as Foucault puts it in his lecture course. In other words, rather than leaving private enterprises alone and letting financial losses be losses, as was generally the case in laissez-faire or liberal government, neoliberal governments use the resources of the state to assist, closely monitor, and intervene in the financial market *for the market's sake*.[29] In actual practice, the largest government aid or subsidies have gone to the fossil fuel industry. How much so? In 2016, government subsidies for fossil fuels, broadly construed, registered around \$5 trillion or an astounding 6.4% of the world's GDP.[30]

Foucault concludes that the reversal of neoliberal capitalism implies that "it is the market that supervises the state and not the other way around."[31] Here's Foucault describing this historical transition from liberalism to neoliberalism succinctly in his 1979 lecture course:

> [I]nstead of accepting a free market defined by the state and kept as it were under state supervision—which was, in a way, the initial formula of liberalism . . .—the ordoliberals say we should completely turn the formula around and adopt the free market as organizing and regulating principle of the state. . . . In other words: a state under the supervision

of the market rather than a market supervised by the state. . . .
This, I think was the reversal they carried out. And what is
important and decisive in current neo-liberalism can, I
think, be situated here.[32]

According to neoliberal theory, then, corporations and
mercenaries are paid to take over the tasks of the state. As
the state is placed "under the supervision of the market,"
financial markets are expanded (by force, if necessary)
and private industries are supported directly.[33]

In actual practice, the United States, the second largest
subsidizer of fossil fuels, spends ten times more on fossil
fuel subsidies than what it spends on education.[34] Even
more astoundingly, with a defense budget the size of the
United States' ($600 billion in 2015), fossil fuel subsidies
have regularly exceeded Pentagon spending ($649 billion
in 2015).[35] A report produced on fossil fuel subsidies by
an institution favorable to neoliberal policies and pro-
grams, the International Monetary Fund (IMF), found
that the underpricing of fossil fuels, due to their subsidi-
zation, was ultimately counterproductive and detrimen-
tal. Broken down, fossil fuel subsidies go to offsetting the
real or actual cost of coal (44%), petroleum (41%), natu-
ral gas (10%), and electricity output (4%), with the argu-
ment being that these subsidies help the overall economy
and the average citizen.[36] Yet according to the IMF
report, "If fuel prices had been set at fully efficient levels
[real prices] in 2015, estimated CO_2 emissions would
have been 28 percent lower, fossil fuel air pollution deaths
46 percent lower, tax revenues [for governments] higher

by 3.8 percent of global GDP, and *net economic benefits . . . would have amounted to 1.7% of global GDP*."[37] What all of this means is not only that neoliberalism aids the destruction of the planet with public funds and wastes tax revenue when it could be better spent on other services. The fundamental neoliberal argument that subsidies benefit ordinary citizens or even the overall economy is untrue.[38]

Solving this predicament will not be easy. Fossil fuels continue to be heavily subsidized by neoliberal governments, frequently without the public's knowledge. For those who have attempted to effect change in their governments, many have discovered that their political institutions are "postdemocratic," or unresponsive to populations; their representatives' primary responsibility today is to private industry rather than to the public.[39] Furthermore, in accordance with neoliberal theory, the responsibility of solving climate issues has been outsourced to the very corporations that benefit from fossil capitalism. Beyond this, as Martin Lukacs points out, neoliberalism has "conned us into fighting climate change as individuals," leading us to focus on how personally green each of us lives and even to build self-capital on this basis.[40] In this climate, the field of environmental ethics has ballooned in the university and, in many ways, actually obfuscated the historical, political, and economic apparatuses of petrocapitalism. Meanwhile, for many populations, democratic revolt is inconceivable. Most cannot imagine how such a thing could ever begin to take place. All the while, there remains

a real sense, in many places, that nothing will change if another candidate or party is elected. And time, unfortunately, is up.

To begin with, democracy at the end of the world would require an end to technocratic governments that subsidize private enterprise at the expense of the public and the planet. It would need to replace a system of distant and self-interested representatives with meaningful participation and delegation. And it would require the immediate installment of a democratic tax or progressive tax system (i.e., a high tax on the wealthy) for the public and the planetary good. But even this, as we will see, is not sufficient. Whatever democracy at the end of these worlds entails, it has to involve a number of fundamental questions: How would a "people" organize themselves differently alongside other forms of life, including other humans and the rest of the planet? How might they mobilize as such and what might compel or hasten their assembly? What would define this new space of appearance? What procedures would make it democratic? Finally, how might this assembly be transformed into a form of power or rule (i.e., a *kratos*)?

PHILOSOPHY AT THE END OF THE WORLD: WYNTER, RENAISSANCE HUMANISM, AND A HATRED OF DEMOCRACY

In addition to understanding the historical processes that produced a certain world, one must study the philosoph-

ical, religious, and political narratives out of which these events transpired. In her famous essay on humanism and colonization, Sylvia Wynter delves into these foundational ideological narratives in an attempt to understand why today, in her words, "20 percent of the world's peoples own 80 percent of its resources, consume two-thirds of its food, and are responsible for 75 percent of its ongoing pollution."[41] Wynter focuses her attention on the birth or genesis of colonialism, the market economy, and the modern state. She then locates the Renaissance philosophy of "man" as corresponding with this entire endeavor. "'[T]he rise of Europe' and its construction of the 'world civilization,'" based on "man," came at the cost of "African enslavement, Latin American conquest, and Asian subjugation," she writes.[42] The intellectual basis for all of this, the Renaissance philosophy of man, would become "the political subject of the state."[43] Furthermore, the "reduction of Man to Labour and of Nature to Land" were the basic foundations that allowed the "market economy" of capitalism to take shape in the Industrial Revolution.[44] In sum, Wynter argues that the modern invention of "man" and the story of man's other would become the European intellectual foundation of racism, colonialism, the state, and capitalism.[45]

Wynter cites from Pico della Mirandola's *Oration on the Dignity of Man* in the opening of her essay on colonialism and humanism, and discusses Pico's philosophy throughout the essay. Pico's *Oration on the Dignity of Man* was composed in 1486 in Italy—six years before the

initial voyage of Columbus—and is seen as one of the more celebrated writings on the Renaissance philosophy of man. In this work, Pico exemplifies a certain Renaissance vision of human exceptionalism, rank, and individualism as he declares that nothing is "more wonderful than man" and investigates man's "rank" in the "universal chain of Being"—a rank that he says is "envied not only by brutes but even by the stars."[46] Commentators describe Pico's *Oration* as a tribute to human beings and an attempt to answer "what really constitutes the superiority of man over other beings."[47] The passage from Pico's *Oration* that Wynter focuses on narrates how God assigned "man" "a place in the middle of the world," "at the world's center"; Pico adds that "[t]he nature of all other beings is limited and constrained within the bounds of laws prescribed by Us."[48]

The locus of racism and colonialism here is not so much that Pico looks down upon other cultures and traditions in the *Oration*.[49] It is rather that, systematically and narratively, Pico's ontological hierarchy and its cartography offer an underlying system of veridiction for levels or tiers of existence among human beings, nonhumans, and the earth. Specifically, Pico introduces a hierarchy of beings, a concept of (a certain) man as superior, a notion of this man being at the "center," and, more specifically, a center that is written about from the point of view of Europe and theorized from out of one's own interior self.[50] Even more importantly for Wynter, this "man" must engage in a "spiritual war" that divides the

world between friends and enemies, good and evil, spirit and flesh, gods and beasts, an interior and a periphery.[51]

For Wynter, Pico's text exemplifies the theoretical foundation for colonialism, racism, and a certain anthropocentrism. Wynter argues that narratives like Pico's permitted Europeans to determine who was human and who was inhuman; to arm themselves with the force of law behind them; to ground themselves in Europe and their own subjectivity; and, ultimately, to enslave others and reduce nature to themselves. Pico, for example, explains that brutes, animals, plants, and matter are beneath humans in order and dignity. Furthermore, the figure of man in the *Oration* is endowed with a special ability to make laws that limit and constrain "all other beings," which forms the narrative basis for the modern state. This hierarchy of beings situates European "man" and his way of life at the center of the world, and as having mastery over all other beings and the earth.

Still, where did Pico's humanism begin? Pico says explicitly that he has "arranged the fruit of [his] thinking on . . . Platonic and Aristotelian philosophy."[52] This includes a certain hierarchy of beings (see Aristotle, *History of Animals*) and the exceptional nature of human beings in particular (see Plato, *Timeaus*, *Protagoras*), as well as the exclusion of other beings from the realm of the political (see Aristotle, *Politics*). In Book I of the *Politics*, for example, Aristotle famously distinguishes between forms of life and explains that the human being (*anthrōpos*) alone is a political animal (*zōon politikon*).[53]

Though this definition of the public sphere is distinctly human, we soon learn that it is the domain of only *certain* humans and not a realm for slaves or women.[54] Elsewhere in Aristotle's *Politics*, Aristotle describes the earth in parasitic terms: when he discusses the elements water and air in Book VII of the *Politics*, for example, he discusses them solely in terms of how they will support the health of the human body.[55]

Following Aristotle, and at the heart of a broader, philosophical conception of the world, philosophers have theorized a false separation between human beings from one another and from other forms of life.[56] Historians have routinely separated human history from natural history, while political theorists have described politics as a distinctly human realm that is somehow completely separate from its environment. In order to create or form a world, we have been told, humans must first separate themselves from other species, from the earth, and from one another in order to form hierarchies, one of which is a perceived separation from the earth itself.

One modern example of this is found in Hannah Arendt's *The Human Condition*, the early chapters of which retrace the steps of Book I of Aristotle's *Politics*. In *The Human Condition*, Arendt follows Aristotle in limiting the world or public realm to a certain form of life that is more than life itself and distinctly human. While "through life man remains related to...other organisms," the "human artifice of the world separates human existence from all mere animal environment"; "life itself,"

Arendt writes, "is outside of this artificial world."[57] Separate from the earth, which is the realm of life itself or *zōē*, "the world, the realm of human affairs," is strictly an endeavor of "human beings."[58] It is a "man-made world," a world of "human artifact, the fabrication of human hands."[59] It requires acts or deeds that are "the exclusive prerogative of man" and have a "specifically human quality," actions that "cannot even be imagined outside of the society of men"—"neither a beast nor a god is capable of [them]."[60] Arendt specifies, following Aristotle, that the specific form of life that is required to inhabit the world excludes the elements, the earth, nonhuman animals, and, she acknowledges, in Aristotle's time placed certain humans "outside the *polis*—slaves and barbarians."[61]

To be clear, this distinction does not mean that Arendt condones slavery,[62] or that she is unconcerned with humans' "present ability to destroy all organic life on earth," "[repudiate] an Earth," or take "flight from the earth into the universe."[63] Still, Arendt makes a sharp separation between the earth and the world and places human beings at the apex of a hierarchy; when she does speak about the earth, it is in parasitic terms as what "[provides] human beings with a habitat in which they can move and breathe" or as "the limited space for the movement of men."[64] The earth thus serves as a backdrop for human actions to form a world. This world, Arendt reminds us hauntingly, "can quite literally endure throughout time until mankind itself has come to an end."[65]

A philosophy for the end of the world must seek the end of "the world" in this sense—a specifically human world that is somehow separate from or distinct from other forms of life, from each other, and the planet. How might we think political worlds that include not only excluded human beings, but other forms of life and the earth?

In this context, Plato's remarks on democracy are very curious, for me, at least. It is not only that Plato resents democracy because in a democracy "purchased slaves" and "women" are equal to free men.[66] It is also that democracy for Plato marks the loss of human rule over nonhumans so that even the latter are free from human dominion.[67] As Plato remarks in the *Republic*, democracy amounts to a form of politics "being planted in the very beasts"; more specifically, he criticizes "the extent to which beasts [*thērion*] subject to human beings [*anthrōpoi*] are freer here [in a democratic city] than in another city."[68] Later in the *Laws*, Plato specifies that "freedom from control must be uncompromisingly eliminated from the life of . . . all the animals under [man's] domination."[69] In addition to a curious equality or politics that extends to nonhumans, Plato discourages humans from becoming like animals because his political system depends on certain humans being exceptional or of a different nature than nature, animals, or other humans. In the passages on poetry or musical education in the *Republic*, Socrates explains that the guardians must never imitate the voices of slaves, women, or workers,[70]

then adds that they should also never imitate nonhumans, especially animals or nature (such as the rustling of the trees).[71] Among other things, the Athenian philosopher is concerned about people imitating "[h]orses neighing, bulls lowing" and "the sound of dogs, sheep, and birds."[72] As we saw in the last chapter, Socrates is also concerned about someone acting as if they were "thunder, the noises of winds, hailstorms,"[73] "the roaring of rivers, the crashing of the sea [...] everything of the sort."[74] Later in Book VIII, and consistent with the well-known ascent and descent of the *Republic*, we find parallel passages that link democracy and anarchy to the equality of animals, women, workers, slaves, foreigners, and youth.[75] There, Plato describes the democratic person as someone reared without aristocratic education who has "intercourse with fiery, clever beasts."[76]

Democracy, at least how Plato describes it, is the political form that is nearest to making equal other forms of life; it is the least exceptional in any regard, including human exceptionalism. Moreover, such a democracy—a nonaristocratic (nontechnocratic) form of government that Plato describes as "oligarchy's enemy"[77]—is also an especially exacting approach for deconstructing the current technocratic political system that sustains the Anthropocene. If democracy is seen by Plato and others as a political form that disrupts Aristotle's and Pico's natural hierarchy of the world—its aristocratic violence among humans and its anthropocentrism among all other beings—then could this hierarchical ordering of

the world, inherited by Pico and by us, and critiqued by Wynter and others, be undone with democracy? Would such an "extreme" form of democracy allow us to think the end of the world concomitantly as one thinks the creation of a new one?

FROM NEOLIBERALISM'S WORLDLESSNESS TO A MULTISPECIES COLLECTIVE

Merely understanding "the fact that for a certain proportion of the world, the entire dismantling of this colonial apparatus is a desired state, launches a call for a different kind of world making," Kathryn Yusoff writes—one that is no longer based on "the enlightenment project of liberal individualism and its exclusions."[78] Still, neoliberalism has been particularly effective in recent decades in obstructing the start of any new world. It has not only made the halls of our congresses impenetrable and "post-democratic" because financial experts know better. It has even done more than militarize our public squares so that one is assailed by weapons of war for appearing in them. Neoliberalism has sought to change the way of life in each of us—it has sought to change the definition of the human being itself.

Instead of being "by nature a political animal (*zōon politikon*),"[79] to quote Aristotle, in an era of neoliberalism, as Foucault explained, "the individual's *life itself* [. . .] must make him into a sort of permanent and multiple

enterprise."[80] In other words, the very definition of the human being must be changed from *homo politicus* to *homo oeconomicus*, or a human being who finds its ultimate meaning as an "entrepreneur of himself" in a free and incessant marketplace.[81]

A "world," Arendt explained, is what is "common to all of us and distinguished from our privately owned place in it." [82] Neoliberalism, by contrast, is a forced "flight . . . from the world into the self," as Arendt might put it.[83] The public realm, "as the common world," Arendt wrote, is the "space within the world which men need to appear at all."[84] But as Judith Butler puts it, even appearing in public space with others is an assault on neoliberalism.[85] This is because appearing with others in public space poses a very real threat to neoliberalism's chief aims: decollectivizing society, isolating human beings, and making them believe that every change is up to the individual. For decades, in fact, neoliberal texts have carefully prescribed a social policy of individualization and competition that opposes all forms of collectivization or socialization.[86] As Barbara Cassin writes in *Google Me*, this social policy was amplified and made global through the apparatuses of big tech and social media.[87] In this sea of individualism, it seems impossible for collective action to take place because the political sphere itself does not properly exist. Under neoliberalism, humans have no *polis* to enter— only a "space of [individual] economic freedom."[88]

And yet, culturally and philosophically, whether we know it or not, we have been transitioning away from

neoliberal life and its focus on individual "human capital" for some time. Each time we hear about strange weather or watch a movie about an archetypal human being overcome by the elements, we take part in a new epic that directly contradicts the neoliberal narrative of individualism and anthropocentricism. At odds with accumulating self-capital or human capital in neoliberal life, the narrative of the Anthropocene introduces the idea of a collective that is situated in a web of life. The story now goes that human beings were never separate from nature, nor do they live as individuals. Rather, in the Anthropocene, life has never been more shared. One is forced, as the reservoirs recede or the smoke blocks the sun for days, to think about history after "the end of history." Beyond the individual, one considers the role and effect of our entire species, even as one knows that all human beings are not equally responsible. One understands increasingly that a change in outcome depends on collective, not individual, action. Still, what further intensifies this sense of collectivity is a shared sense of catastrophe—a historical and eschatological sense that we seem to be on the brink of catastrophe *together*.[89] As Chakrabarty put it in his 2009 essay "The Climate of History" there is a new sense of history that "arises from a shared sense of a catastrophe,"[90] and this understanding destroys "the distinction between natural and human histories."[91]

A sea change is taking place before us. On a profound cultural level, the Anthropocene is forcing a shift in our

poetics from an *I* to a *we*. This epic situates our human lives in a web of life. It collectivizes and historicizes us. This sense of a historical collective is intensified by *increasingly* catastrophic events and made more than human. Because of this, the philosopher Bruno Latour has claimed that the Anthropocene "may become the most pertinent philosophical, religious, anthropological, and [. . .] political concept for beginning to turn away for good from the notions of 'Modern' and 'modernity.'"[92]

Still, another different political factor hastens our transition out of neoliberalism even more quickly. What we have witnessed in many places over the last decade is the explosive growth of populisms against neoliberal ways of life and government. As Marc Crépon and Bernard Stiegler put it in their book on democracy, we are well into a worldwide "crisis of political representation" and a potentially dangerous political era of anything but.[93] Politically, as Chantal Mouffe and others have argued, we are living in a historic moment of collective, populist rage. This historic moment, argues Mouffe in her 2018 book *For a Left Populism*, can be more accurately defined as "the expression of resistances against the post-democratic condition brought about by thirty years of neoliberal hegemony," a hegemony which "has now entered into crisis."[94] While some groups are responding to technocratic neoliberal governments with participatory assemblies and slogans like "this is what democracy looks like," others are resisting neoliberalism with ethnic nationalisms and the myth of a "people." Consider, for example, the names of

far right, ethnonationalist groups like the Swiss People's Party, the Austrian Freedom Party, the Swedish Democrats, the Danish People's Party, or Geert Wilders's Party for Freedom.[95] The perverse effectiveness of these groups is partly based on their appeal to a fraternal or ethnic "people" precisely at a time when solidarity and collective identity has been missing from our lives.

What all of this means is that, in addition to living at the end of the Holocene, we are nearing an end where democracy is up for grabs and being redefined by all parties and on all sides. We are living in a period of revaluation of democracy's *dēmos*—a contest for the next era's interpretation of democracy and its future—that obliges us to enter into the fray of it. We can already see before us another vision emerging of a different kind of "people" at the end of the world. What remains to be seen is whether a form of populist resistance to technocratic or neoliberal governments could emerge that would not be authoritarian or identitarian in nature, but democratic in its political form and in its way of life. As Michael Hardt and Antonio Negri write in their 2017 book *Assembly*, "[W]e are living in a phase of transition," and "protest is not enough. . . [W]e must also ask what kind of power we want and, perhaps more important, who we want to become."[96]

THIS IS WHAT DEMOCRACY LOOKS LIKE

And so, as geologists signal that we have firmly left the Holocene, and political philosophers and theorists see

multiple signs of a neoliberal order crumbling, we are standing at the end of a certain world asking how another world is possible. Democracy is not the only alternative political form, but a certain democracy proposes a serious, timely, and targeted alternative to the Anthropocene as a Capitalocene. As a political system, it proposes the antithesis of neoliberalism: a nontechnocratic form of government that Plato describes as "oligarchy's enemy."[97] As a way of life and politics, it eliminates hierarchies among human beings,[98] and it is the closest political form to making equal other forms of life.[99] Finally, in stark contrast to the White supremacist groups above, democracy—a rule of a people or *dēmos*—offers a just and egalitarian approach for reclaiming *anthrōpoi* in an Anthropocene. And yet, if we wish to inherit or take up a word like democracy, we will have to change the meaning of all of its names, beginning with ours.

Continental philosophers have long expressed concerns about the distance between representative governments and actual democracy.[100] As Wendy Brown puts it in *Undoing the Demos: Neoliberalism's Stealth Revolution* (2015), democratic governments have not merely been stymied by advocates of neoliberalism over the last four decades—they have been "hollowed out from within."[101] Instead of listening to constituents and adopting reforms, representative governments are increasingly defined by what philosophers like Jacques Rancière have called "postdemocracy," or a politics in which expert representatives no longer feel the need to listen to their constituents

in order to govern.[102] In the end, what we call democratic representation today is an antidemocratic form of oligarchy, hierarchy, and exclusion.[103]

The "real difference between democracy and oligarchy," as Aristotle put it, "is poverty and wealth. Wherever men rule by reason of their wealth . . . that is an oligarchy, and where the poor rule, that is a democracy."[104] Democracy comes into being, as Plato said, "when the poor win . . . [and] share the regime and the ruling offices . . . on an equal basis."[105] By contrast, as Jacques Rancière puts it in *Hatred of Democracy*, "Representation . . . is not a form in which democracy has been adapted to modern times and vast spaces. It is, by rights, an oligarchic form, a representation of minorities who are entitled to take charge of public affairs."[106] Rancière explains:

> [W]e can specify the rules that lay down the minimal conditions under which a representative system can be declared democratic. . . . [W]hat we call democracy is a statist and government functioning that is exactly the contrary: eternally elected members . . .; representatives of the people that largely come from one administrative school; ministers or their collaborators who are also given posts in public or semipublic companies; fraudulent financing of parties through public works contracts; businesspeople who invest colossal sums in trying to win electoral mandates; owners of private media empires that use their public functions to monopolize the empire of the public media. In a word: the monopolizing of *la chose publique* by a solid alliance of State oligarchy and economic oligarchy.[107]

In Book VI of the *Politics*, Aristotle recorded a very different set of democratic procedures, institutions, and "kinds of democracy" in the ancient Mediterranean world, including the way democrats managed "the scrutiny of accounts . . . and private contracts."[108] "[I]n the manner of the political equality of speech [*isēgoria*]," wrote the "Old Oligarch," "we have put slaves on equal terms with free men and metics with citizens."[109] "And we almost forgot to mention the extent of the law of equality and of freedom in the relations of women with men and men with women," he added.[110] Thucydides wrote that a democracy "throws open [its] city to the world, and never by alien acts exclude foreigners [*xenēlasia*] from any opportunity."[111] He and others also gendered democracy as feminine and associated it not with freedom itself, but specifically with the freedom to pursue *pleasure*.

As Thucydides explained, whereas others "seek after manliness, at Athens we live exactly as we please."[112] Plato criticized democracy in this regard for being "too soft (*malakos*),"[113] a "sweet regime,"[114] or "fair" like "boys and women looking at many-colored things."[115] More historically, Plato says that Athens's more "extreme" or *radical* mutation of democracy rejected what he calls "paternal care" when it came into being several years after the Battle of Salamis;[116] the masses "refuse[d] to obey the admonitions of their fathers" and "cease[d] to care about oaths and promises and religion."[117] Instead, the multitude instituted "pleasure"—occupational pleasure, creative pleasure,

sexual pleasure—as a touchstone for whether something was good or not.[118] This most certainly included what Plato later calls, in the *Laws*, an "unnatural [crime] of the first rank" that requires legislation: same-sex pleasure, which Plato prohibits and makes a crime because unlike in heterosexual couples, in "homosexual intercourse and lesbianism . . . men and women cannot control their desire for pleasure."[119]

Democracy's *pleasure* meant that work *stopped* "for the mind to refresh itself from business," said Thucydides; it also encouraged a kind of public art and leisure that was enjoyed with others—in Athens, we "celebrate . . . all the year round," said Thucydides.[120] This gendered description of democracy reappears when Plato describes how the democrats treat those who should be punished or disciplined. "Isn't the gentleness towards the condemned exquisite?" Socrates says of democracy.[121] Still, the most curious descriptions of Athens's "extreme" form of democracy for me are those moments when Plato hints at a posthuman form of politics—when he hints at a freedom or equality that goes beyond human beings. As we have seen, Plato speaks of democracy as "being planted in the very beasts" and criticizes "the extent to which beasts [*thērion*] subject to human beings [*anthrōpoi*] are freer here [in a democratic city] than in another city."[122]

ASSEMBLING AT THE END OF THE
WORLD: APPEARING IN PUBLIC SPACE
AS A *POST*HUMAN CONDITION

The terrible fact is that democracy and its *pleasure* will not save us. For ultimately, the reality the Anthropocene enjoins us to is *not* that the rich consume far more than the poor or contribute far more to global warming than anyone else (they do). It is the awful irony that if more people are lifted out of poverty, without dramatic changes in the way we live in the environments around us, more people will consume more meat, use more air conditioning, and engage in other human activities that accelerate climate change. Democracy at the end of the world, then, would have to mean more than harvesting an emerging collective and historical form of power for the sake of a new commons and an end to the Capitalocene. Democracy would not only have to be won, but transformed into a kind of zoocracy, a rule or assembly of all the living.

In 1993, Bruno Latour called for such a democracy when he spoke of a "democracy [that] could be extended to things themselves."[123] "It is time, perhaps, to speak of democracy again," wrote Latour, "but of a democracy extended to things themselves."[124] In *We Have Never Been Modern*, Latour went on to describe a "parliament of things" in which law and politics would not be centered on humans, but around life itself.[125] Similarly, in 2006, David Wood proposed extending Derrida's notion

of "democracy-to-come" to a "parliament of the living." Wood wrote, "Consider too how we might rework Derrida's idea of a democracy-to-come in an environmental context," or make a transition from deconstruction to econstruction.[126] In *What's These Worlds Coming To?*, Jean-Luc Nancy proposed that we create new worlds of "all the living together."[127] What Nancy calls "struction" after deconstruction is the creation of new assemblages or worlds that involve nonhumans. Nancy describes: "[W]e are in a spiraling, growing pile of pieces . . . a mass that renders the distinction between . . . 'man' and 'nature' . . . less and less possible for us."[128]

Donna Haraway, in her popular 2015 essay on the Anthropocene, argues for something like this when she proposes a "flourishing for rich, multispecies assemblages that include people"—something she admits may or may not be possible.[129] This approach begins with developing a deeper notion of "kin" that includes nonhumans. As Haraway writes, "Earthlings are kin in the deepest sense, and it is past time to practice better care of kinds-as-assemblages (not species one at a time). Kin is an assembling sort of word."[130] She concludes: "I think our job is to make the Anthropocene as short/thin as possible and to cultivate with each other in every way imaginable epochs to come that can replenish refuge."[131] Haraway even provides us with a slogan for this approach: "Make Kin, Not Babies!"

In sum, a new form of political association is needed that would necessarily involve a robust "natural contract"

with the earth, as Michel Serres formulated it. Just as Jakob von Uexküll's "Umwelt" expanded a certain philosophical idea of the world, Michel Serres's "natural contract" critiques political forms of association or assemblages that define political life as separate from "nature." Serres proposes new political forms of association that have mutually beneficial or reciprocal relationships with nonhuman forms of life. Because, ultimately, as Serres put it, "Immersed in the exclusively social contract . . . [n]one of [the politician's] speeches spoke of the world: instead they endlessly discussed men."[132] As Serres wrote in 1990:

> Back to nature! That means we must add to the exclusively social contract a natural contract of symbiosis and reciprocity in which our relationship to things would set aside mastery and possession in favor of admiring attention, reciprocity, contemplation, and respect; where knowledge would no longer imply property, nor action mastery. . . . [A] parasite, which is what we are now, condemns to death the one he pillages and inhabits, not realizing that in the long run he's condemning himself to death too. The parasite takes all and gives nothing; the host gives all and takes nothing. . . . Conversely, rights of symbiosis are defined by reciprocity: however much nature gives man, man must give that much back to nature, now a legal subject.[133]

This new form of association, if it is ever to challenge neoliberalism seriously, must also be accompanied by a notion of appearing in public space. Rousseau, whom Serres targets with his *natural* contract, nevertheless rightly understood the importance of the masses appearing in

public space frequently.[134] Likewise, in his work on representative government, Kropotkin sought to remind those living under modern representative governments that frequent assembly in public space would be necessary. "Freedom of the press, criticism of the laws, freedom of meeting and association—all were extorted by force, by agitations that threatened to become rebellions. It was by establishing trade unions and practicing strike action despite the edits of Parliament and the hangings of 1813, and by wrecking the factories hardly fifty years ago, that the English workers won the right to associate and to strike."[135]

The failure of political thought throughout the twentieth century (and prior, of course) was to limit this "the space of appearance" to "the lifeblood" or "web of human affairs," as Arendt put it, instead of thinking a space of appearance for life itself and for the web of life.[136] What we require is a kind of appearance in public space that belongs to more than the *human condition*, and even to more than the appearance of those human beings in the margins of the human condition. This would amount to rethinking "the space of appearance in the widest sense of the word," as Arendt described it. It would mean transforming that space of appearance—"where men exist not merely like other living or inanimate things but make their appearance explicitly"—into a space where the distinction between human and nonhuman appearance no longer has any cause or reason.[137] It would be as though the human "wall of the *polis* and . . . boundaries of the

law" were removed.[138] It would mean speaking (with bare voices) and acting together with other forms of life and the planet. A "multitude, appearing . . . in broad daylight."[139] In daylight itself.

More recently, Isabelle Stengers has described the Anthropocene as the "intrusion of Gaia" into this space—a way the earth appears in our politics whether we like it or not.[140] As Stengers argues very impressively, Gaia has already announced the new regime. She is *intruding* on us whether we like it or not. She is not even particularly interested in our response. She is not threatened by us because she "will effectively continue to participate in her regime of existence, that of a living planet."[141] In her new regime, our "epic versions of human history"[142]—"man" understanding that he is "master of his own fate"[143]— now look obsolete.[144] As Stengers puts it, "Gaia, she who intrudes, *asks nothing of us*, not even a response to the question she imposes. . . . Gaia is indifferent to the question of 'who is responsible?' and doesn't act as a righter of wrongs."[145] This doesn't justify "any kind of indifference whatsoever on our part with regard to the threats that hang over the living beings that inhabit the earth with us. It simply isn't Gaia's affair."[146] Stengers continues, we know "that those affected first will be the poorest on the planet, to say nothing of all those beings that have nothing to do with the affair."[147]

Following the work of Lovelock, Stengers says that we would have to reduce the population of human beings "to about 500 million in order to pacify Gaia and live

reasonably well in harmony with her."[148] Elsewhere, Donna Haraway has spoken with some hope of a number of "2 or 3 billion" a "couple hundred years from now."[149] Facing such a mountain, one has to return to the art we examined in Chapter Two with a fresh eye and a different realization. One also has to seriously propose a politics that resists what Stengers calls "the coming barbarism," or what we can already imagine will be different ways of thinking about a "people" at the end of the world. As Ta-Nehisi Coates put it differently in *Between the World and Me*, "[T]he process of naming 'the people' has never been a matter of genealogy or physiognomy so much as one of hierarchy."[150]

In sum, the earth is already speaking in a new political forum. She has already announced the new regime. It seems to me that part of philosophy's responsibility in this era is to deconstruct forms of life and thought that separate ourselves from the earth, that exclude other forms of life and each other, and propose a way of life and thought that does the opposite. We must enlarge the public sphere and learn how to make visible those who are invisible, including other species and the earth. An entirely new form of assemblage is needed: a different relationship between humans and the rest of the earth that permits the flourishing of life itself or *zōē*. Only a multispecies approach to a new kind of worldmaking will do.

CONCLUSION

How do we live at the end of the world? How do we enjoy, love, or mourn? What do we talk about with our friends?

How do we construct a public sphere that is not distinctly human, or separate from our environment or natural world? How do we assemble with the task of making visible other species and other forms of life? What is a political thinking that would have, at least as an aim, a return to a *holos* or whole relationship again with the rest of the earth? Finally, how much will it take to repair the legacy of racism and colonialism on the part of human beings? Only the end of the world will do, Du Bois imagines. And we must sit here, with this thought, for a long time. In *Black Skin, White Masks*, Frantz Fanon describes himself, ultimately, as "a slave not to the 'idea' others have of me, but to my appearance . . . because the white Gaze, the only valid one, is already dissecting him," defining him as "a new type of man, a new species."[151] For this reason, Fanon says, he "[arrives] slowly into the world; sudden emergences are no longer my habit."[152] How can he too rush to appear in a world at the end of the world, in the fullness of his own historical reality?

Bruno Latour writes in *Facing Gaia*:

> There is no cure for the condition of belonging to the world. But, by taking care, we can cure ourselves of believing that we do not belong to it, that the essential question lies elsewhere, that what happens to the world does not concern us.

The time is past for hoping "to get through it." We are indeed . . . "in a tunnel," except that we won't see light at the end. In these matters, hope is a bad counselor . . . We can no longer say, "this, too, will pass." . . . [This means] discovering a different way of experiencing the passage of time. Instead of speaking of hope, we would have to explore a rather subtle way of "dis-hoping"; this does not mean despairing.[153]

As a short book, this book poses more questions than it answers. But these questions are proposals to you for further thought. How might "we" inherit the term Anthropocene, or whatever one chooses to call it? How might this story collectivize us at a time when *any* idea of a collective, including humankind, is seen as a threat? How should we write the reinvention of epic? How might this epic introduce a new sense of history—one that excavates the shadow archives of human history, destroys the axioms of individualism and human exceptionalism, and situates our species in a web of life? Finally, can all of this assist us in a new ecoegalitarian project in a way that may have been unthinkable before? The Anthropocene seems, at least, to offer a new sense of history that reinforces an old idea: that "we" still exist in a world and that change is still entirely possible.

The first chapter of this book on *time*, as it relates to history, has proposed a counterhistory for human beings for the Anthropocene. The second chapter has concerned *art* as it relates to epic and the emerging traits of an art beyond postmodern art. The final chapter on *politics* has proposed a radical form of democracy (a rule of a people

or *dēmos*) on the part of humans that must be won and reconceived as a *zoocracy*, a rule of all of the living together that gives or sustains life itself. Although I think what Latour says above about "hope" rings true, it seems to me that a new environmental commons is far more than a romantic pipedream today. Due to a number of philosophical, cultural, political, economic, and environmental factors, we are living in a moment when historic political change is not only possible, but inevitable. Another *world* is, in fact.

In *To Our Friends*, the Invisible Committee suggests that a *better* world begins with "*a different idea of life*,"[154] with "knowing what a desirable form of life would be."[155] Likewise, Giorgio Agamben argues in his essay "The Friend" that this life must first be shared among friends.[156] What must be shared is life itself—the fact that we are alive, that we exist, despite the way we are forced to live. "What is at stake is living itself," Agamben writes more recently. A form of power that "coincides completely . . . with . . . *living a life*."[157] What I am proposing here is that this life be thought of more broadly as a certain friendship or democracy of all of the living. Friends, let's keep living. Now is the time to assemble as friends with all of the living.

ACKNOWLEDGMENTS

Thank you to the American Philosophical Association for holding a symposium on my research on this topic at its Eastern Division Meeting in New York City in January 2019. In particular, I would like to thank respondents Sandra McCalla of the University of the West Indies and Kip Redick of Christopher Newport University for their thought-provoking comments on my paper.

Thank you to Gabriel Rockhill and participants of the Atelier de Théorie Critique at the École des hautes études en sciences sociales in Paris, France, in June 2019 for their comments on a fledgling draft of "Democracy at the End of the World," and for their education, activism, and solidarity during the *Gilets jaunes* (yellow vests) protests over that summer.

Thank you to Chiara Ricciardone for inviting me in July 2019 to write an article on this topic for *The Philosopher* journal in London. Special thanks to *The Philosopher* and its editor Anthony Morgan for agreeing to reprint

portions of that article, "A Genealogy for the End of the World: For a Counterhistory of Human Beings in the Anthropocene," in chapter 1 of this work.

Thank you to the other faculty members and students at the Collegium Phenomenologicum in Città di Castello, Italy, in July 2019 with whom this project was initially discussed. In particular, I would like to thank Matthias Fritsch, Ted Toadvine, Mauro Senatore, Anne O'Byrne, and Bettina Bergo for encouraging this project and for being wonderful interlocutors with their astute observations and questions.

Thank you to Dipesh Chakrabarty for his responses to my questions at "The Meaning of Climate Change: Dipesh Chakrabarty with Travis Holloway" event for *The Philosopher*'s Spring 2021 Lecture Series, organized by Anthony Morgan. Thanks also to Dipesh Chakrabarty for allowing me to interview him on this topic separately, and to Peg Birmingham for agreeing to publish this interview in *Philosophy Today*.

Thank you to the faculty in the Department of Government, Law, and Finance at the Externado University of Columbia (Bogotá), and to the Society for Italian Philosophy for inviting me to present work from Chapter Three of this book in November 2020 and in September 2021, respectively.

Thank you to Babette Babich and Maximilian Gregor Hepach for our dialogue and collaboration on the philosophy of weather.

Thank you to my colleague May Joseph at the Pratt Institute for encouraging this project and supporting the initial development of this book proposal. Without this mentorship and support, the book would never have been written.

Thank you to students in my course on the Anthropocene at the Pratt Institute, where we read major works on the Anthropocene and thought about them alongside contemporary works of art. Thanks also to students in my neoliberalism and democracy seminar at Vassar College for a study that helped me understand our current historical moment better.

Thank you to the organizers and to the other participants in the seminar "The Geological Turn," which took place at the American Comparative Literature Association's (ACLA) annual meeting in Los Angeles in 2019. Special thanks to Christopher Walker of Colby College for his suggestions for my work on this topic over the years.

Thank you, always, to my kind, brilliant colleagues at the State University of New York at Farmingdale, as well as the Office of the Dean of the School of Arts and Sciences and the Provost's Office for their support.

Thank you to the people of New York who continue to show me what democracy looks like, including throughout the pandemic and the protests for racial justice.

Thank you, finally, to my family and my friends for being there when the world was gone—when my wonderful mother passed away from cancer in February 2021

while I was writing this book. In addition to being an extraordinary person and mom to us, my mother devoted her life to caring for people as a nurse. I feel lucky to have known her, let alone to have had her for a mom. This book is because of her and thanks to her.

NOTES

INTRODUCTION

1. In explaining the experience of the sublime in nature in Section 28 of the *Critique of Judgment*, Kant writes: "[W]e found in our mind a superiority over nature itself in its immensity. . . . [Nature's might] reveals in us . . . an ability to judge ourselves independent of nature, and reveals in us a superiority over nature," in Immanuel Kant, *Critique of Judgment*, trans. Werner S. Pluhar (Indianapolis: Hackett, 1987), 120–1; see also, for example, Percy Bysshe Shelley's "Mont Blanc: Lines Written in the Vale of Chamouni" (1817 version), in which he writes: "Dizzy Ravine! and when I gaze on thee / I seem as in a trance sublime and strange / To muse on my own separate fantasy, / My own, my human mind," in *The Complete Poetry of Percy Bysshe Shelley: Volume Three*, eds. Neil Fraistat and Nora Crook (Baltimore, MD: Johns Hopkins University Press, 2012), 79–88.

2. Bruno Latour, *Down to Earth: Politics in the New Climatic Regime*, trans. Catherine Porter (Cambridge, UK: Polity, 2018), 2.

3. For a description of neoliberalism as a specific historical mutation of capitalism in the twentieth century that is distinct

from so-called liberalism, see my article "Neoliberalism and the Future of Democracy," in *Philosophy Today* 62, no. 2 (Summer 2018): 627–650.

4. Elizabeth Marks, Caroline Hickman, Panu Pihkala, Susan Clayton, Eric R. Lewandowski, Elouise E. Mayall et al., "Young People's Voices on Climate Anxiety, Government Betrayal and Moral Injury: A Global Phenomenon," available at SSRN: https://ssrn.com/abstract=3918955 or http://dx.doi .org/10.2139/ssrn.3918955.

5. Pierre Rosanvallon, *Counter-Democracy: Politics in an Age of Distrust*, trans. Arthur Goldhammer (New York: Cambridge University Press, 2008), 1, 28. France's political chair at the Collège de France, Pierre Rosanvallon, argues that representative governments around the world have witnessed the statistical "erosion of citizens' confidence in political leaders and institutions" over the past twenty-five years. Rosanvallon cites rates of trust and voting abstentions in multiple studies, including: Dogan, *Political Mistrust and the Discrediting of Politicians*; Capdevielle, *Démocratie*; and Franklin, *Voter Turnout and the Dynamics of Electoral Competition in Established Democracies since 1945*.

6. Hannah Arendt, *The Human Condition* (Chicago: University of Chicago Press, 1958), 1.

7. Arendt, *The Human Condition*, 1.

8. Arendt, 1.

9. Arendt, 2.

10. "To anyone I've offended," said Elon Musk to applause on a May 2021 *Saturday Night Live* episode during the Covid-19 pandemic, "I just want to say I reinvented electric cars and I'm sending people to Mars on a rocket ship." See "'SNL': Read Full Transcript of Elon Musk's Opening Monologue on 'Saturday Night Live,'" *Newsweek*, https://www.newsweek.com/snl -read-full-transcript-elon-musks-opening-monologue-saturday -night-live-1589849, accessed August 17, 2021.

11. Arendt, 1. My italics.

12. David D. Kirkpatrick and Ben Hubbard, "Coronavirus Invades Saudi Inner Sanctum," *New York Times*, April 8, 2020.

13. Peter Beaumont, Sarah Boseley, and Jessica Glenza, "Provider of Trump Covid Drug Is President's Golf Friend," *The Guardian*, October 8, 2020.

14. Ruchir Sharma, "The Billionaire Boom: How the Super-Rich Soaked Up Covid Cash," *Financial Times*, May 14, 2021.

15. Arendt, *The Human Condition*, 1, 2, 6, 262. My italics.

16. Latour, *Down to Earth*, 2.

17. See, for example, Donna Haraway, "Anthropocene, Capitalocene, Plantationocene, Chthulucene: Making Kin," *Environmental Humanities* 6 (2015): 160; Phillip John Usher, "Untranslating the Anthropocene," *Diacritics* 44, no. 3 (2016): 56–77; Christine Cuomo, "Against the Idea of an Anthropocene Epoch: Ethical, Political and Scientific Concerns," *Biogeosystem Technique* 4.1 (2017): 4–8.

18. Jacques Derrida, *Advances*, trans. Philippe Lynes (Minneapolis: University of Minnesota Press, 2017), 48.

19. Cf. Martin Heidegger, *The Fundamental Concepts of Metaphysics*, trans. William McNeill and Nicholas Walker (Bloomington: Indiana University Press, 1995), 184–185. Here Heidegger presents "three theses" describing the stone as worldless (*weltlos*), the animal as poor in world (*weltarm*), and man as world-forming (*weltbildend*). Likewise, in *The Human Condition*, "the world, the realm of human affairs," is strictly an endeavor of "human beings" (Arendt, *The Human Condition,* 247). Arendt goes to explain: "[T]he world itself . . . is not identical with the earth or with nature . . . as the general condition of organic life. It is related, rather, to the human artifact, the fabrication of human hands, as well as to affairs which go on among those who inhabit the man-made world togetherthe world, like every in-between, relates and separates men at the same time" (Arendt, 52). The world is made

up of acts or deeds that are "the exclusive prerogative of man" and have a "specifically human quality," actions that "cannot even be imagined outside of the society of men"—"neither a beast nor a god is capable of it" (Arendt, 22–23).

20. Derrida, *Advances*, 48.

21. *Donna Haraway: Story Telling for Earthly Survival*, directed by Fabrizio Terranova, 2016.

22. Jacques Derrida, *Rogues: Two Essays on Reason*, trans. Pascale-Anne Brault and Michael Naas (Stanford, CA: Stanford University Press, 2005), 9.

23. Arendt, *The Human Condition*, 22, 52.

24. Michel Serres, *The Natural Contract*, trans. Elizabeth MacArthur and William Paulson (Ann Arbor: University of Michigan Press, 1995), 43.

25. Arendt, *The Human Condition*, 1, 6, 222, 248. See in particular Arendt's notion of world alienation (chapter VI), Sputnik as an "'escape from men's imprisonment to the earth'" (prologue, 1), and her discussion of the telescope and the development of a new science that "considers the nature of the earth from the viewpoint of the universe" (chapter VI, 248).

26. Jeffrey Jerome Cohen, *Stone: An Ecology of the Inhuman* (Minneapolis: University of Minnesota Press, 2015), 63.

27. Donna Haraway, *Staying with the Trouble: Making Kin in the Chthulucene* (Durham, NC: Duke University Press, 2016), 4, 103.

28. On the question of epic or grand narrative, see in particular Jean-François Lyotard's *The Postmodern Condition*, trans. Geoff Bennington and Brian Massumi (Minneapolis, MN: University of Minnesota Press, 1984). Lyotard writes: "We no longer have recourse to grand narratives" or epic in contemporary society (60); "The grand narrative has lost its credibility, regardless of what mode of unification it uses" (37), and "the little narrative [*petit récit*] remains the quintessential form of imaginative invention" (60) in our time.

29. Kathryn Yusoff, *A Billion Black Anthropocenes or None* (Minneapolis: University of Minnesota Press, 2018), xi.

30. For a conversation on the problem of a phenomenological experience of climate change, see "The Meaning of Climate Change: Dipesh Chakrabarty with Travis Holloway," in *Philosophy Today*, forthcoming 2022. For an analysis of the relationship between scientific knowledge and narrative knowledge in "postmodern" society, see Jean-François Lyotard, *The Postmodern Condition: A Report on Knowledge*, trans. Geoff Bennington and Brian Massumi (Minneapolis: University of Minnesota Press, 1984).

31. Isabelle Stengers, *In Catastrophic Times: Resisting the Coming Barbarism* (Lüneburg: Open Humanities Press, 2015), 46.

32. Plato, *Republic*, 557a. Unless otherwise noted, all translations of Plato's *Republic* are of those of Allan Bloom in Plato, *The Republic*, trans. Allan Bloom (New York: Basic Books, 1991).

33. "Old Oligarch," *Constitution of Athens*, 1.13. All translations are those found in Pseudo-Xenophon, *The Old Oligarch: Pseudo-Xenophon's Constitution of Athens*, trans. K. R. Hughes, M. Thorpe, and M. A. Thorpe (London: London Association of Classical Teachers, 1968).

34. "Old Oligarch," *Constitution of Athens*, 2.9–10.

35. Plato, *Republic*, 562c; 563c.

36. Thucydides, 2.29. Translation modified from Thucydides, *History of the Peloponnesian War*, trans. C. F. Smith (Cambridge, MA: Harvard University Press, 1919), 325.

37. "Old Oligarch," 1.12. Translation modified. Plato, *Republic*, 563b

38. See, for example, Arendt, *The Human Condition*, 52. Cf. Serres, *The Natural Contract*, 38.

39. Bruno Latour, *We Have Never Been Modern* (Cambridge, MA: Harvard University Press, 1993), 142.

40. David Wood proposes extending Derrida's "democracy-to-come" to a "parliament of the living." See David Wood, "On the Way to Econstruction," *Environmental Philosophy* 3, no. 1 (Spring 2006): 35–46.

CHAPTER 1

1. See Neil Roberts, *The Holocene: An Environmental History*, 2nd ed. (Malden, MA: Wiley-Blackwell, 2014), 22–23.

2. Christophe Bonneuil and Jean-Baptiste Fressoz, *The Shock of the Anthropocene: The Earth, History, and Us*, trans. David Fernbach (New York: Verso, 2017), 3.

3. Bonneuil and Fressoz, *The Shock of the Anthropocene*, 50; Donna J. Haraway, *Staying with the Trouble: Making Kin in the Chthulucene* (Durham, NC: Duke University Press, 2016), 44.

4. For a specialized discussion of the factors contributing to this recommendation, see Colin N. Waters et al., "The Anthropocene Is Functionally and Stratigraphically Distinct from the Holocene," *Science* 351, no. 6269 (January 2016), http://science.sciencemag.org/content/351/6269/aad2622.full. For an accessible, journalistic overview of this declaration, see Damian Carrington, "The Anthropocene Epoch: Scientists Declare Dawn of Human-Influenced Age," *The Guardian*, August 29, 2016, https://www.theguardian.com/environment/2016/aug/29/declare-anthropocene-epoch-experts-urge-geological-congress-human-impact-earth. The Anthropocene Working Group voted in May 2019, with 88 percent approval, to recommend to the ICS that the Anthropocene "be treated as a formal chronostratigraphic unit" in geological time; 88 percent also voted in favor of dating the beginning of the Anthropocene around the mid-twentieth century of the common era (see minutes from the Anthropocene Working Group of the Subcommission on Quaternary Stratigraphy, released May 21, 2019. Available at:

http://quaternary.stratigraphy.org/working-groups/anthropo
cene/).

5. Friedrich Nietzsche, *The Birth of Tragedy and the Geneal-
ogy of Morals*, trans. Francis Golffing (New York: Random
House, 1956), 154–155.

6. Sylvia Wynter, "Unsettling the Coloniality of Being/
Power/Truth/Freedom: Towards the Human, After Man, Its
Overrepresentation—An Argument," *CR: The New Centennial
Review* 3, no. 3 (2003), 266.

7. See Kathryn Yusoff, *A Billion Black Anthropocenes or
None* (Minneapolis: University of Minnesota Press, 2018), 31;
Christophe Bonneuil and Jean-Baptiste Fressoz, *The Shock of
the Anthropocene*, 16; and Simon Lewis and Mark A. Maslin,
"Defining the Anthropocene," *Nature* 519, March 12, 2015:
171–180.

8. Michel Foucault, *The Archaeology of Knowledge*, trans. A.
M. Sheridan Smith (New York: Pantheon, 1972), 17. Ironically,
as an enemy of a certain humanism and subject-oriented
thinking, Foucault writes that this historical method offers "a
method of historical analysis freedom from the anthropological
theme" or "anthropologism" (16).

9. Dipesh Chakrabarty, *The Climate of History in a Plane-
tary Age* (Chicago: University of Chicago Press, 2021), 2, 15.
This book republishes Chakrabarty's original 2009 essay "The
Climate of History: Four Theses," elaborates on this essay, and
responds to criticisms of it.

10. Chakrabarty, *The Climate of History in a Planetary Age*, 10.

11. Chakrabarty, "The Climate of History: Four Theses,"
Critical Inquiry 35 (Winter 2009): 206.

12. Chakrabarty, "The Climate of History," 221–222. My
italics.

13. Chakrabarty, 222.

14. Chakrabarty, *The Climate of History in a Planetary Age*, 18.

15. Chakrabarty, "The Climate of History," 221.

16. Chakrabarty, 214, 222.

17. Dipesh Chakrabarty, *Provincializing Europe: Postcolonial Thought and Historical Difference* (Princeton, NJ: Princeton University Press, 2000).

18. Amitav Ghosh, *The Great Derangement: Climate Change and the Unthinkable* (Chicago: University of Chicago Press, 2016), 115.

19. Bonneuil and Fressoz, *The Shock of the Anthropocene*, 66.

20. Bonneuil and Fressoz, 67.

21. Bonneuil and Fressoz, 66. For Dipesh Chakrabarty's response to these criticisms, see my forthcoming interview with Chakrabarty in *Philosophy Today*, "The Meaning of Climate Change: Dipesh Chakrabarty with Travis Holloway."

22. Yusoff, *A Billion Black Anthropocenes or None*, 12.

23. Yusoff, xi, 11–12.

24. Michel Serres, *The Natural Contract*, trans. Elizabeth MacArthur and William Paulson (Ann Arbor, MI: University of Michigan Press, 1995), 38.

25. Elizabeth Marks, Caroline Hickman, Panu Pihkala, Susan Clayton, Eric R. Lewandowski, Elouise E. Mayall et al., "Young People's Voices on Climate Anxiety, Government Betrayal and Moral Injury: A Global Phenomenon," available at SSRN: https://ssrn.com/abstract=3918955 or http://dx.doi.org/10.2139/ssrn.3918955.

26. Pierre Rosanvallon, *Counter-Democracy: Politics in an Age of Distrust*, trans. Arthur Goldhammer (New York: Cambridge University Press, 2008), 1, 28.

27. See, for example, Donna Haraway, "Anthropocene, Capitalocene, Plantationocene, Chthulucene: Making Kin," *Environmental Humanities* 6 (2015): 160; Phillip John Usher, "Untranslating the Anthropocene," *Diacritics* 44, no. 3 (2016): 56–77; Christine Cuomo, "Against the Idea of an Anthropo-

cene Epoch: Ethical, Political and Scientific Concerns," *Biogeo-system Technique* 4.1 (2017): 4–8.

28. Yusoff, *A Billion Black Anthropocenes or None*, 14.

29. *Donna Haraway: Story Telling for Earthly Survival*, directed by Fabrizio Terranova, 2016.

30. Haraway, *Staying with the Trouble*, 31.

31. Janae Davis, Alex A. Moulton, Levi Van Sant, and Brian Williams, "Anthropocene, Capitalocene, . . . Plantationocene?: A Manifesto for Ecological Justice in an Age of Global Crises," *Geography Compass* 13, no. 5 (April 2019).

32. Bonneuil and Fressoz, *The Shock of the Anthropocene*, 116.

33. Haraway, *Staying with the Trouble*, 47.

34. In addition to new concepts, concepts like Jakob von Uexküll's "Umwelt" or Michel Serres's "natural contract" have been brought into relief and reinherited. Serres's "natural contract," for example, critiques social contract theories that defined themselves as separate from or against "nature" and simultaneously argues for contracts with nonhuman forms of life. See Serres, *The Natural Contract*, 38.

35. Haraway, *Staying with the Trouble*, 103, 102.

36. Haraway, 30.

37. Haraway, 100.

38. Rosi Braidotti, "Four Theses on Posthuman Feminism," in *Anthropocene Feminism*, ed. Richard Grusin (Minneapolis: University of Minnesota Press, 2017), 23.

39. Wynter, "Unsettling the Coloniality of Being/Power/Truth/Freedom," 266.

40. Wynter, "Unsettling the Coloniality of Being/Power/Truth/Freedom," 288.

41. Wynter, 266.

42. Wynter, 265.

43. Yusoff, *A Billion Black Anthropocenes or None*, 30.

44. Chakrabarty, *The Climate of History in a Planetary Age*, 111.

45. Lewis and Maslin, "Defining the Anthropocene," 171–80.

46. Chakrabarty, *The Climate of History in a Planetary Age*, 106.

47. Chakrabarty, 167.

48. Chakrabarty, 186.

49. Chakrabarty, 184–188.

50. Chakrabarty, 111.

51. Chakrabarty, 106–110.

52. Kathleen D. Morrison, "Provincializing the Anthropocene," *Seminar* 673 (September 2015): 79.

53. Cf. Chakrabarty, *The Climate of History in a Planetary Age*, 168–169.

54. Friedrich Nietzsche, *The Birth of Tragedy and the Genealogy of Morals*, trans. Francis Golffing (New York: Random House, 1956), 209.

55. Nietzsche, 209–211.

56. Chakrabarty, *The Climate of History in a Planetary Age*, 17–18.

57. Jennifer Telesca, *Red Gold: The Managed Extinction of the Giant Bluefin Tuna* (Minneapolis: University of Minnesota Press, 2020).

58. Haraway, *Staying with the Trouble*, 31, 55.

59. Haraway, *Staying with the Trouble*, 55.

CHAPTER 2

1. See also, for example, Naomi Klein, *The Shock Doctrine: The Rise of Disaster Capitalism* (New York: Metropolitan Books, 2007); Col. Tamzy J. House et al., "Weather as a Force Multiplier: Owning the Weather in 2025," Defense Technical Information Center, August 1, 1996, https://apps.dtic.mil/sti/citations/ADA333462; Peter Sloterdijk, *Terror from the Air*, trans.

Amy Patton and Steve Corcoran (Cambridge, MA: MIT Press, 2009).

2. According to the US Global Change Research Program's most recent National Climate Assessment, "There is broad agreement in the literature that human factors (greenhouse gases and aerosols) have had a measurable impact on the observed oceanic and atmospheric variability in the North Atlantic, and there is *medium confidence* that this has contributed to the observed increase in Atlantic hurricane activity since the 1970s." In addition, "Both theory and numerical modeling simulations generally indicate an increase in tropical cyclone (TC) intensity in a warmer world, and the models generally show an increase in the number of very intense TCs. For Atlantic and eastern North Pacific hurricanes and western North Pacific typhoons, increases are projected in precipitation rates (*high confidence*) and intensity (*medium confidence*). The frequency of the most intense of these storms is projected to increase in the Atlantic and western North Pacific (*low confidence*) and in the eastern North Pacific (*medium confidence*)." See J. P. Kossin et al., *Climate Science Special Report: Fourth National Climate Assessment*, vol. 1 (Washington, DC: USGCRP, 2017): 114–132, 257–276. The IPCC's recently released Working Group I draft report of the Sixth Assessment Report (not yet published at the time of publication) updates this study with new scientific projections about catastrophic weather.

3. Michel Foucault, *The Order of Things* (New York: Vintage, 1994), 387.

4. Jacques Derrida, "Structure, Sign, and Play in the Discourse of the Human Sciences," in *Writing and Difference*, trans. Alan Bass (Chicago: University of Chicago Press, 1978), 292–293.

5. Immanuel Kant, *Critique of Judgment*, trans. Werner S. Pluhar (Indianapolis: Hackett, 1987), 120–21.

6. Kant, *Critique of Judgment*, 120–1.

7. Kant, 120.

8. Kant, 120–121.

9. "Sarah Anne Johnson," Montreal Museum of Fine Arts, accessed January 18, 2017, https://www.mbam.qc.ca/en/acqui sitions/sarah-anne-johnson/.

10. Kant, *Critique of Judgment*, 120.

11. Cf. Heather Davis and Etienne Turpin, eds., *Art in the Anthropocene* (London: Open Humanities Press, 2015), and The Invisible Committee, *To Our Friends* (Los Angeles: Semiotext(e), 2015), 32.

12. Anne Washburn, *Mr. Burns: A Post-Electric Play*, Playwrights Horizons/Productions in Print (Hanover: Smith and Kraus, 2013).

13. Washburn, *Mr. Burns*, 30.

14. See the playright's statement in "Playright's Perspective: Anne Washburn," in Anne Washburn, *Mr. Burns*, iii–iv.

15. See the playright's statement in "Playright's Perspective: Anne Washburn," in Anne Washburn, *Mr. Burns*, iii–iv.

16. On this creative choice, see: Anne Washburn, *Interview of Anne Washburn on Mr. Burns, a Post-Electric Play*, Playwrights Horizons, August 30, 2013. https://www.youtube.com/watch?v=dRo1Ez6kFZw

17. Washburn, *Interview of Anne Washburn on Mr. Burns.*

18. Washburn.

19. Washburn.

20. Washburn.

21. Act 3, *Mr. Burns*.

22. Hannah Arendt, *The Human Condition* (Chicago: University of Chicago Press, 1958), 52, 233.

23. Roland Barthes, "The Death of the Author," in *Image - Music - Text*, trans. Stephen Heath (New York: Farrar, Straus and Giroux), 143.

24. Michel Foucault, *The Archaeology of Knowledge*, trans. A. M. Sheridan Smith (New York: Pantheon, 1972), 17.

25. See, for example, I. S., "Writing the End of the World: Charting Trends in Apocalyptic and Post-Apocalyptic Fiction," *The Economist*, April 12, 2017, https://www.economist.com/blogs/prospero/2017/04/writing-end-world.

26. Andrew Durbin, *Mature Themes* (New York: Nightboat, 2014), 96.

27. *The Arcadia Project: North American Postmodern Pastoral*, ed. Joshua Corey and G. C. Waldrep (Boise, ID: Ashanta/Boise State Press, 2012).

28. See, for example, Alastair Macaulay, "Merce Cunningham's Multifaceted Mirror, Held Up to Nature," January 6, 2017, https://www.nytimes.com/2017/01/06/arts/dance/merce-cunninghams-multifaceted-mirror-held-up-to-nature.html. One exception to this is the recent work of Andreas Gursky. See, for example, Andreas Gurksy's *Les Mées*, 2016, c-type print, 2.2 x 3.7 m.

29. Isabelle Stengers, *In Catastrophic Times: Resisting the Coming Barbarism* (Lüneburg: Open Humanities Press, 2015), 46.

30. Roy Scranton, *Learning to Die in the Anthropocene: Reflections on the End of a Civilization* (San Francisco: City Lights, 2015).

31. Cf. Gilbert Garcin, *Il faut penser aux consequences*, 2012. Gelatin silver print. (photo: Lisa Sette Gallery); Gilbert Garcin, *Candidat de droite*, 2012. Gelatin silver print. (photo: Lisa Sette Gallery).

32. Barthes, "The Death of the Author," 143.

33. Gilles Deleuze and Felix Guattari, *A Thousand Plateaus*, trans. Brian Massumi (Minneapolis: University of Minnesota Press, 1987), 3.

34. Jean-François Lyotard's *The Postmodern Condition*, trans. Geoff Bennington and Brian Massumi (Minneapolis, MN: University of Minnesota Press, 1984), 60.

35. Lyotard, 37, 60.

36. Lyotard, 82.

37. Lyotard, 37, 60.

38. Lyotard, 20, 61. Lyotard's exploration of *catastrophe* as a destabilizing "model of legitimation" or "paralogy" is very interesting in this context (59–61).

39. Friedrich Nietzsche, *The Birth of Tragedy* and *The Genealogy of Morals*, trans. Francis Golffing (New York: Random House, 1956), 23. In his genealogy of tragedy, Nietzsche describes the transition from early tragedy to Greek tragedy as a transition from a "oneness with nature" (27) or "the product of formative forces arising directly from nature" (24) to a separation from nature or the indirect "imitation of nature" through "the mediation of the human artist" (24–25). This is why, for Nietzsche, in the Greek's Dionysian dithyramb, "man" expresses "the desire . . . to sink back into the original oneness of nature" (27). Through Dionysiac rites, Nietzsche explains, "nature itself . . . rises again to celebrate the reconciliation with her prodigal son, man" (23). As Nietzsche explains further, by this time, Greek tragedy had suffered "an irrecoverable loss. It is as though in these Greek festivals a sentimental trait of nature were coming to the fore, as though nature were bemoaning the fact of her fragmentation, her decomposition into separate individuals" (27).

40. See, in particular, Richard D. McKirahan, "Anaximander of Miletus," in *Philosophy before Socrates: An Introduction with Texts and Commentary*, 2nd ed. (Indianapolis: Hackett, 2010), 41: "Anaximander says that these [thunder, lightning, thunderbolts, waterspouts, and hurricanes] all result from wind. For whenever it [wind] is enclosed in a thick cloud and forcibly escapes because it is so fine and light, then the bursting [of the cloud] creates the noise and the splitting creates the flash against the blackness of the cloud (Aëtius 3.3.1)."

41. See note 45 above.

42. Nietzsche, *The Birth of Tragedy*, 27. Cf. note 45 above.

43. Sophocles, *Antigone*, 332–375, in *The Three Theban Plays*, trans. Robert Fagles (New York: Penguin, 1982), 76–77. Cf. Gregory Crane, "Creon and the 'Ode to Man' in Sophocles' Antigone," *Harvard Studies in Classical Philology* 92 (1989), 103–16.

44. Ibid.

45. Plato, *Apology*, 18d, 19c; Diogenes Laertius, *Lives of Eminent Philosophers*, 5. 18.

46. Aristophanes, *The Clouds*, 218–233, 253. Translation from Aristophanes' *Clouds*, in Plato and Aristophanes, *Four Texts on Socrates*, trans. Thomas G. West and Grace Starry West (Ithaca, NY: Cornell University Press, 1984), 125.

47. Aristophanes, *The Clouds*, 341, 354. "[W]hat is the reason that if, as you say, they are Clouds, they to-day as women appear to our view?" asks Strepsiades, in Aristophanes, *The Clouds*, in *Aristophanes* I, trans. Benjamin Bickley Rogers (London: Loeb, 1926), 295.

48. Aristophanes, *The Clouds*, 316, 343. As Socrates clarifies, the clouds are not mortal; they simply appear that way (316). Nor is Zeus responsible for them; they are a result of a simple vortex of air (377).

49. Aristophanes, *The Clouds*, 230. As Homer's use of the term *homoios* illustrates, the word can also be used to describe something being "equal in force" or "a match for something." Cf. *Iliad* 23.632.

50. Aristophanes, *The Clouds*, 390. Translation from Aristophanes' *Clouds*, in Plato and Aristophanes, *Four Texts on Socrates*, trans. Thomas G. West and Grace Starry West (Ithaca, NY: Cornell University Press, 1984), 132.

51. Aristophanes, *The Clouds*, 405. Translation from *Four Texts on Socrates*, 133.

52. Aristophanes, *The Clouds*, 228–230. Cf. 316. Translation is that of William James Hickie in Aristophanes, *Clouds*, in *The Comedies of Aristophanes* (London: Bohn, 1853).

53. See the *LSJ* dictionary for a list of references.

54. Aristophanes, *The Clouds*, 316.

55. Plato, *Republic*, 393a–c. To understand this phenomenon better, we might think of the theory of "method acting" in theater, in which an actress imagines that she actually becomes the persona of the character she acts.

56. Plato, *Republic*, 397a.

57. Plato, *Republic*, 396b–c. Here Socrates is also concerned about the separation of man and animal, as he censures the imitation of "[h]orses neighing, bulls lowing" (396b–c) and "the sound of dogs, sheep, and birds" (397a).

58. Friedrich Hölderlin, "Evening Fantasy," in *Poems and Fragments*, 4th bilingual ed., trans. Michael Hamburger (London: Anvil Press Poetry, 2004), 133.

59. Quentin Meillassoux, *After Finititude: An Essay on the Necessity of Contingency*, trans. Ray Brassier (London: Bloomsbury, 2008), 5.

60. Meillassoux, *After Finititude*, 7.

61. Meillassoux, 7.

62. Nevertheless, for Meillassoux, Heidegger only achieves this turn by considering a new, different relationship between humans and nature—the "co-propriation (*Zusammengehörigkeit*) of man and being, which [Heidegger] calls *Ereignis*," Meillassoux, *After Finititude*, 8.

63. Martin Heidegger, *Hölderlin's Hymns: "Germania" and "The Rhine,"* trans. William McNeill and Julia Ireland (Indianapolis: Indiana University Press, 2014), 110.

64. Heidegger, *Hölderlin's Hymns*, 30.

65. Heidegger, 30.

66. Cf. Heidegger, 81, where Heidegger specifies in Section 8: "It would be . . . erroneous to place attunements in the subject as only 'subjective appearances'—as appearances arising in the interiority of the subject . . . Rather the Dasein of the

human being is transposed into attunements equiprimordially together with beings as such."

67. Foucault, *The Order of Things*, 387.

68. Martin Heidegger, *Being and Time*, trans. John Macquarrie and Edward Robinson (San Francisco: Harper, 1962), 320. As Macquarrie and Robinson note, Heidegger's original German is "Der Ruf kommt *aus* mir und doch über mich."

CHAPTER 3

1. Aimé Césaire, *Return to My Native Land*, trans. John Berger and Anna Bostock (Brooklyn: Archipelago Books, 2013), 39.

2. Hannah Arendt, *The Human Condition* (Chicago: University of Chicago Press, 1958), 54.

3. Saidiya Hartman, "The End of White Supremacy, An American Romance," in *Bomb Magazine* no. 152 (Summer 2020), https://bombmagazine.org/articles/the-end-of-white-supremacy-an-american-romance/.

4. W.E.B. Du Bois, "The Comet," in *Darkwater: Voices from within the Veil* (New York: Harcourt, Brace and Howe, 1920), 253–54.

5. Du Bois, "The Comet," 268.

6. Du Bois, 268.

7. Du Bois, 270.

8. Du Bois, "The Souls of White Folk," in *Darkwater: Voices from within the Veil* (New York: Harcourt, Brace and Howe, 1920), 30.

9. Du Bois, "The Comet," 268.

10. Du Bois, 264.

11. Simon Lewis and Mark A. Maslin, "Defining the Anthropocene," *Nature* 519, March 12, 2015: 171–180. Some estimates put the initial indigenous population as high as 61

million. Cf. Christophe Bonneuil and Jean-Baptiste Fressoz, *The Shock of the Anthropocene: The Earth, History, and Us*, trans. David Fernbach (New York: Verso, 2017), 16; Kathryn Yusoff, *A Billion Black Anthropocenes or None* (Minneapolis: University of Minnesota Press, 2018), 31.

12. Lawrence Gross, *Anishinaabe Ways of Knowing and Being* (New York: Routledge, 2014), 33, as cited in Kyle Powys Whyte, "Indigenous Science (Fiction) for the Anthropocene: Ancestral Dystopias and Fantasies of Climate Change Crises," *Environment and Planning E: Nature and Space* 1, no. 1–2 (2018), 227. I would like to thank Prof. Ted Toadvine for this reference, which was included in a lecture that he gave at the Collegium Phaenomenologicum in Città di Castello, Italy in July of 2019.

13. Saidiya V. Hartman, *Scenes of Subjection: Terror, Slavery, and Self-Making in Nineteenth Century America* (New York: Oxford University Press, 1997), 3.

14. Frantz Fanon, *The Wretched of the Earth*, trans. Richard Philcox (New York: Grove Press, 2004), 5, 3; James Baldwin, *No Name in the Street* (New York: Vintage Books, 1972), 1.

15. Yusoff, *A Billion Black Anthropocenes or None*, xiii.

16. Césaire, *Return to My Native Land*, 39.

17. Yusoff, *A Billion Black Anthropocenes or None*, 101.

18. Bonneuil and Fressoz, *The Shock of the Anthropocene*, 116, 71, 61, 124.

19. Donna J. Haraway, *Staying with the Trouble: Making Kin in the Chthulucene* (Durham, NC Duke University Press, 2016), 47.

20. Jason W. Moore, ed., *Anthropocene or Capitalocene? Nature, History, and the Crisis of Capitalism* (Oakland, CA: PM Press, 2016), 4. Cf. Jason Moore, *Capitalism and the Web of Life: Ecology and the Accumulation of Capital* (London and New York: Verso, 2015), and Andreas Malm, *Fossil Capitalism: The Rise of Steam Power and the Roots of Global Warming* (London and New York: Verso, 2016).

21. Moore, *Anthropocene or Capitalocene?*, 6.

22. Bonneuil and Fressoz, *The Shock of the Anthropocene* 229.

23. Yusoff, *A Billion Black Anthropocenes or None*, 30.

24. Bonneuil and Fressoz, *The Shock of the Anthropocene*, 11, 117.

25. Bonneuil and Fressoz, 221–233.

26. See, for instance, Michel Foucault, *The Birth of Biopolitics: Lectures at the Collége de France*, trans. Graham Burchell, eds. Michel Senellart, François Ewald, Alessandro Fontana, Arnold I. Davidson (New York: Palgrave Macmillan, 2008), 116; Derrida, *Specters of Marx*, trans. Peggy Kamuf (New York: Routledge, 1994), 46, 87–88; Étienne Balibar, *Citizenship*, trans. Thomas Scott-Railton (Cambridge: Polity, 2015), 6; Judith Butler, *Notes toward a Performative Theory of Assembly* (Cambridge, MA: Harvard University Press, 2015), 11–18; The Invisible Committee, *To Our Friends*, trans. Robert Hurley (South Pasadena, CA: Semiotext(e), 2015), 27, 190; Pierre Dardot and Christian Laval, *The New Way of the World: On Neoliberal Society* (London and New York: Verso, 2009); Michael Peters, *Poststructuralism, Marxism, and Neoliberalism* (Lanham, MD: Rowman and Littlefield, 2001); Wendy Brown, *Undoing the Demos: Neoliberalism's Stealth Revolution* (Brooklyn: Zone Books, 2015); Cornel West, "Goodbye, American Neoliberalism," *The Guardian*, November 17, 2016, https://www.theguardian.com/commentisfree/2016/nov/17/american-neoliberalism-cornel-west-2016-election; Nancy Fraser, "The End of Progressive Neoliberalism," *Dissent Magazine*, January 2, 2017, https://www.dissentmagazine.org/online_articles/progressive-neoliberalism-reactionary-populism-nancy-fraser; David Harvey, *A Brief History of Neoliberalism* (Oxford: Oxford University Press, 2005). Neoliberalism has become an increasingly accepted name among Continental philosophers and political theorists for a set of economic policies beginning anywhere from the late 1970s to the early 1980s.

27. See, for example, Brown, *Undoing the Demos*, 9, 17; Butler, *Notes toward a Performative Theory of Assembly*, 11; Balibar, *Citizenship*, 6.

28. Foucault, *The Birth of Biopolitics*, 116

29. Foucault, 133.

30. David Coady, Ian Parry, Nghia-Piotr Le, and Baoping Shang, "Global Fossil Fuel Subsidies Remain Large: An Update Based on Country-Level Estimates," IMF Working Paper WP/19/89, *International Monetary Fund*, May 2019, https://www.imf.org/~/media/Files/Publications/WP/2019/WPIEA2019089.ashx.

31. Foucault, *The Birth of Biopolitics*, 116.

32. Foucault, 116–117.

33. Foucault, 116.

34. Foucault, *The Birth of Biopolitics*, 116. Cf. Tim Dickinson, "Study: U.S. Fossil Fuel Subsidies Exceed Pentagon Spending," *Rolling Stone*, May 8, 2019, https://www.rollingstone.com/politics/politics-news/fossil-fuel-subsidies-pentagon-spending-imf-report-833035/.

35. Coady et al., "Global Fossil Fuel Subsidies Remain Large."

36. Coady et al..

37. Coady et al.. My italics.

38. Coady et al..

39. Jacques Rancière, *En quel temps vivons-nous?* (Paris: La fabrique éditions, 2017); Jacques Rancière, *Hatred of Democracy*, trans. Steve Concoran (London: Verso, 2006).

40. Martin Lukacs, "Neoliberalism Has Conned Us into Fighting Climate Change as Individuals," *The Guardian*, July 17, 2017, available online: https://www.theguardian.com/environment/true-north/2017/jul/17/neoliberalism-has-conned-us-into-fighting-climate-change-as-individuals.

41. Sylvia Wynter, "Unsettling the Coloniality of Being/Power/Truth/Freedom: Towards the Human, after Man, Its

Overrepresentation—An Argument," *CR: The New Centennial Review* 3, no. 3 (2003), 260–61.

42. Wynter, 263.

43. Wynter, 263.

44. Sylvia Wynter, "Jonkonnu in Jamaica: Towards the Interpretation of Folk Dance as a Cultural Process," *Jamaica Journal* 4, no. 2 (June 1970): 35.

45. Wynter, "Unsettling the Coloniality of Being/Power/Truth/Freedom," 260.

46. Giovanni Pico della Mirandola, "Oration on the Dignity of Man," in *The Renaissance Philosophy of Man*, trans. Elizabeth Livermore Forbes, eds. Ernst Cassirer, Paul Oskar Kristeller, and John Herman Randall (Chicago: University of Chicago Press, 1948), 223.

47. Paul Oskar Kristeller, *Renaissance Concepts of Man and Other Essays* (New York: Harper & Row, 1972), 9, 12.

48. Pico, "Oration on the Dignity of Man," 224, 225; Wynter, "Unsettling the Coloniality of Being/Power/Truth/Freedom," 259, 260.

49. See, for example, Pico, "Oration on the Dignity of Man," 242, 244.

50. Pico, "Oration on the Dignity of Man," 224, 226, 227, 231; Wynter, "Unsettling the Coloniality of Being/Power/Truth/Freedom," 278–279.

51. Pico, 224, 226, 227, 231; Wynter, 278–279.

52. Pico, 245.

53. Aristotle, *Politics*, 1253a1–10. Unless otherwise noted, all translations of Aristotle's *Politics* are those of B. Jowett in *The Complete Works of Aristotle*, vol. 2, ed. Jonathan Barnes (Princeton, NJ: Princeton University Press, 1984). Translation revised by author. Aristotle explains that it is "characteristic of man that he alone has any sense of good and evil, of just and unjust, and the like, and the association of living beings who have this sense makes…a polis" (Aristotle, *Politics*, 1253a15–18). For

Aristotle, human beings alone are able to communicate about these matters together due to their "gift of speech," while animals have only voices that indicate pleasures and pains (Aristotle, *Politics*, 1253a10–11).

54. Aristotle, *Politics* 1259b18–1260b24. Later in the *Politics*, Aristotle suggests more specifically that the "best form of a state first determine which is the most eligible life" or "best life," according to or inquiring into "the natural order of things," in *Politics* 1323a15–22.

55. Aristotle, *Politics*, 1330b1–10.

56. In his *Letter on Humanism*, Heidegger explained that while "plants and animals are lodged in their respective environments," those environments do not truly constitute a "world" in the sense human beings create through language, in Martin Heidegger, "Letter on Humanism," trans. Frank A. Capuzzi, in *Pathmarks*, 248–249; 262–3; 246–248. In *The Fundamental Concepts of Metaphysics*, Heidegger presented "three theses" describing the stone as worldless (*weltlos*), the animal as poor in world (*weltarm*), and "man" as world-forming (*weltbildend*), in Martin Heidegger, *The Fundamental Concepts of Metaphysics*, trans. William McNeill and Nicholas Walker (Bloomington: Indiana University Press, 1995), 184–185. In the *Elucidations*, Heidegger almost seems to reproduce Pico's cosmogony for human beings in his reading of "man" in Hölderlin, in Martin Heidegger, *Elucidations of Hölderlin's Poetry*, trans. Keith Hoeller (Amherst: Humanity Books), 64, 113.

57. Arendt, *The Human Condition*, 2.

58. Arendt, 2, 247.

59. Arendt, 52.

60. Arendt, 22–3.

61. Arendt, 27.

62. See, for example, Arendt, 55.

63. Arendt, 3, 6.

64. Arendt, 2, 52.

65. Arendt, 233.

66. Plato, *Republic*, 563b.

67. Plato, *Republic*, 562c; 563c.

68. Plato, *Republic*, 562c; 563c.

69. Plato, *Laws*, 942d. Unless otherwise noted, all translations of Plato's *Laws* are by Trevor J. Saunders in *Plato: Complete Works*, ed. John M. Cooper (Indianapolis: Hackett, 1997).

70. Plato, *Republic*, 395 d–e; 396a–b.

71. Plato, *Republic*, 396b.

72. Plato, *Republic*, 396b–c; 397a.

73. Plato, *Republic*, 397a.

74. Plato, *Republic*, 396b–c.

75. Plato, *Republic*, 562e–563c.

76. Plato, *Republic*, 559d–e.

77. Plato, *Republic*, 557a; Plato, *Laws*, 640a.

78. Yusoff, *A Billion Black Anthropocenes or None*, 12–13.

79. Aristotle, *Politics*, 1.2, 3.6; *Nicomachean Ethics*, 1.1–2.

80. Foucault, *The Birth of Biopolitics*, 241. My italics.

81. Foucault, 226.

82. Hannah Arendt, *The Human Condition*, 52.

83. Arendt, 6.

84. Arendt, 52, 208.

85. Butler, *Notes toward a Performative Theory of Assembly*, 16.

86. Foucault, *The Birth of Biopolitics*, 144. Not surprisingly, this pedagogy was encouraged in the university: a privileging of the authors of individualism, human exceptionalism, abstract logic, and "science," or the ever-present threat of "totalitarianism" precluded a thinking of history, politics, and the environment.

87. Barbara Cassin seeks to disassociate the term democracy from Silicon Valley in particular in *Google Me: One-Click Democracy*, trans. Michael Syrotinski (New York: Fordham University Press, 2018). For a somewhat contrasting view about

the possibilities for new online public forums, see Marc Crépon and Bernard Stiegler, *De la démocratie participative: fondements et limites* (Paris: Mille et une nuits, 2007).

88. Foucault, *The Birth of Biopolitics*, 116.

89. Chakrabarty, "The Climate of History," 222.

90. Chakrabarty, 221–222.

91. Chakrabarty, 206.

92. Bruno Latour, *Facing Gaia: Eight Lectures on the New Climactic Regime*, trans. Catherine Porter (Cambridge: Polity, 2017), 116.

93. Crépon and Stiegler, *De la démocratie participative*, 25. My translation.

94. Chantal Mouffe, *For a Left Populism* (New York: Verso, 2018), 79.

95. Cf. Pippa Norris. "Authoritarian Populism Is Rising Across the West. Here's Why," *Washington Post*, March 11, 2016.

96. Michael Hardt and Antonio Negri, *Assembly* (New York: Oxford University Press, 2017), xiii.

97. Plato, *Republic*, 557a; Plato, *Laws*, 640a.

98. Plato, *Republic*, 563b.

99. Plato, *Laws*, 942d.

100. On the gap between the name "democracy" and government, see, for instance, Jean-Luc Nancy, "Finite and Infinite Democracy," in *Democracy, In What State?*, trans. William McCuaig (New York: Columbia University Press, 2011), 58; Miguel Abensour, *Democracy against the State*, trans. Max Blechman and Martin Breaugh (Malden, MA: Polity, 2011), xxi; Jean-Luc Nancy, *The Truth of Democracy*, trans. Pascale-Anne Brault and Michael Naas (New York: Fordham University Press, 2010), 37–41; Jacques Rancière, *Hatred of Democracy*, trans. Steve Concoran (London: Verso, 2006), 92; Jacques Derrida, *Rogues: Two Essays on Reason*, trans. Pascale-Anne Brault and Michael Naas (Stanford, CA: Stanford University Press, 2005 [2003]), 89–90; Michael Hardt and Antonio Negri,

Multitude: War and Democracy in the Age of Empire (New York: Penguin Books, 2004), 232.

101. Brown, *Undoing the Demos*, 18.

102. Jacques Rancière, *Disagreement: Politics and Philosophy* (Minneapolis: University of Minnesota Press, 1999), 102–03.

103. "Old Oligarch," 1.9.

104. Aristotle, *Politics*, 1280a1–5.

105. Plato, *Republic*, 557a; Plato, *Republic*, 556c; Plato, *Republic*, 558c. Or as Aristotle puts it in the *Politics*, in a democracy, "all should rule over each, and each in his turn over all," in Aristotle, *Politics*, 1317b20.

106. Rancière, *Hatred of Democracy*, 53.

107. Rancière, 72–73.

108. Aristotle, *Politics*, 6.2–3.

109. "Old Oligarch," 1.12. Translation modified.

110. Plato, *Republic*, 563b..

111. Thucydides, 2.29. Translation modified from Thucydides, *History of the Peloponnesian War*, trans. C. F. Smith (Cambridge, MA: Harvard University Press, 1919), 325.

112. Thucydides, 2.39. Plato, *Republic*, 557b, 556e.

113. Plato, *Republic*, 556 b–c; 558a–b. Cf. Plato, *Laws*, 2. In these specific passages in the *Republic*, "softness" or "gentleness" is not a virtue; it is not the gentle soul that later resists strong emotions in the *Republic* (387e) or counters the Bacchic frenzy of the Muse in the *Phaedrus* (245a). It is a delicate- or sweet-toned sound that causes the soul to assume the same sweet or soft disposition (Plato, *Republic*, 411a–b).

114. Plato, *Republic*, 558c.

115. Plato, *Republic*, 557c.

116. Cf. Plato, *Republic*, 562d, 563b, 556b–c, 558a–c, 559d; Aristotle, *Athenian Constitution*, 28; Plato, *Laws*, 701b. Cf. Aristotle, *Politics*, 1290a28 and Aristotle, *On Things Heard*, 803a20, 803a8.

117. Plato, *Laws*, 701b.

118. Plato, *Laws*, 700e. Cf. Plato, *Laws*, 657e–658b.

119. Plato, *Laws*, 636c. The Athenian tells us that "when male and female come together in order to have a child, the pleasure they experience seems to arise entirely naturally. But homosexual intercourse and lesbianism seem to be unnatural crimes of the first rank, and are committed because men and women cannot control their desire for pleasure."

120. Thucydides, 2.38.

121. Plato, *Republic*, 557e.

122. Plato, *Republic*, 562c; 563c.

123. Bruno Latour, *We Have Never Been Modern* (Cambridge, MA: Harvard University Press, 1993), 142.

124. Latour, *We Have Never Been Modern*, 142.

125. Latour, 142–145.

126. David Wood, "On the Way to Econstruction," *Environmental Philosophy* 3, no. 1 (Spring 2006): 35–46.

127. Jean-Luc Nancy and Aurélien Barrau, *What's These Worlds Coming To?*, trans. Travis Holloway and Flor Méchain (New York: Fordham, 2014), 52–54.

128. Nancy and Barrau, *What's These Worlds Coming To?*, 49, 52.

129. Donna Haraway, "Anthropocene, Capitalocene, Plantationocene, Chthulucene: Making Kin," *Environmental Humanities* 6 (2015): 160.

130. Haraway, "Anthropocene, Capitalocene, Plantationocene, Chthulucene," 162.

131. Haraway, 160.

132. Michel Serres, *The Natural Contract*, trans. Elizabeth MacArthur and William Paulson (Ann Arbor: University of Michigan Press, 1995), 43.

133. Serres, *The Natural Contract*, 38.

134. Jean-Jacques Rousseau, *Social Contract*, in *The Collected Writings of Rousseau*, vol. 4, eds. Roger D. Masters and Chris-

topher Kelly, trans. Judith R. Bush, Roger D. Masters, and Christopher Kelly (Hanover, NH: University Press of New England, 1994), 191. As Rousseau wrote at the close of Book III of his *Social Contract*, "the instant the People is legitimately assembled as a Sovereign body, all jurisdiction of the Government ceases, the executive power is suspended, and the person of the humblest Citizen is as sacred and inviolable as that of the first Magistrate; because where the Represented person is, there is no longer any Representative."

135. Peter Kropotkin, from "Representative Government," in *Words of a Rebel*, trans. George Woodcock (Montréal: Black Rose Books, 1992), 124.

136. Arendt, *The Human Condition*, 204.

137. Arendt, 199. My italics.

138. Arendt, *The Human Condition*, 198.

139. Hannah Arendt, *On Revolution* (New York: Penguin, 2006), 38.

140. Isabelle Stengers, *In Catastrophic Times: Resisting the Coming Barbarism* (Lüneburg: Open Humanities Press, 2015), 44; Bruno Latour, *Facing Gaia*.

141. Stengers, *In Catastrophic Times*, 46–47.

142. Stengers, 47.

143. Stengers, 47.

144. Stengers, 46.

145. Stengers, 46.

146. Stengers, 46.

147. Stengers, 46.

148. Stengers, 47.

149. Haraway, *Staying with the Trouble*, 103.

150. Ta-Nehisi Coates, *Between the World and* Me (New York: Spiegel & Grau, 7).

151. Frantz Fanon, *Black Skin, White Masks*, trans. Richard Philcox (New York: Grove, 2008), 95.

152. Fanon, *Black Skin, White Masks*, 95.

153. Latour, *Facing Gaia,*13.

154. The Invisible Committee, *To Our Friends*, 52.

155. The Invisible Committee, *To Our Friends*, 45, 49.

156. See Aristotle's discussion of friendship as *synaisthēsis* or shared aesthetics at Aristotle *Eth. Nic.* 1170a28–117Ib35; and Giorgio Agamben's discussion of this passage in Giorgio Agamben, "The Friend," in *What Is an Apparatus?*, trans. David Kishik and Stefan Pedatella (Stanford, CA: Stanford University Press, 2009), 25–37.

157. Giorgio Agamben, "What Is a Destituent Power?," trans. Stephanie Wakefield, *Environment and Planning D: Society and Space* 32 (2014): 73, 74.

CPSIA information can be obtained
at www.ICGtesting.com
Printed in the USA
JSHW051201071022
31413JS00002B/2